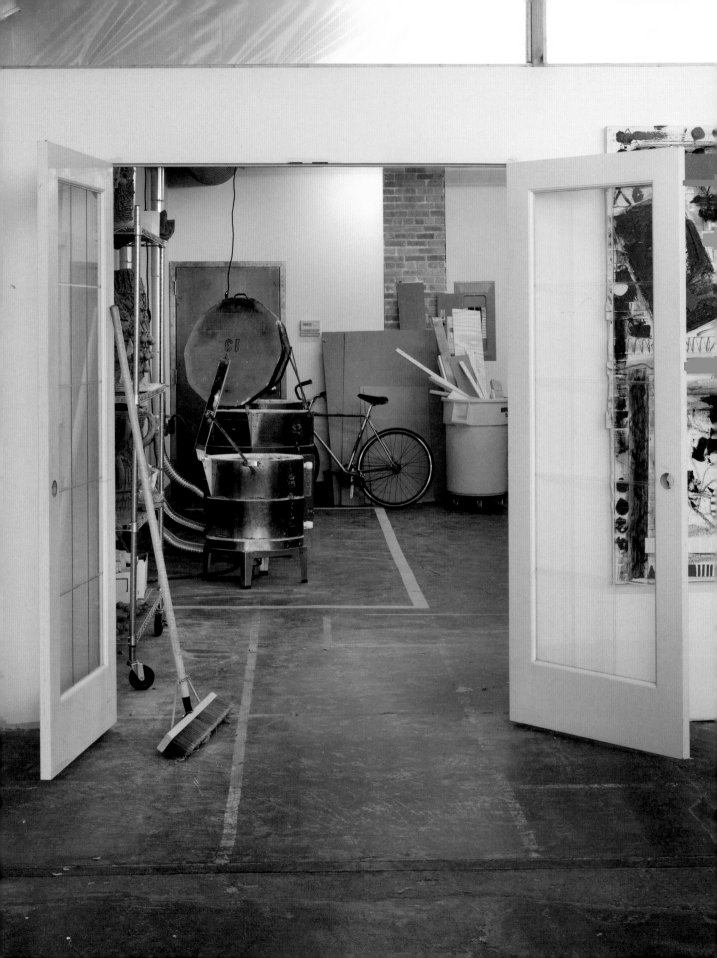

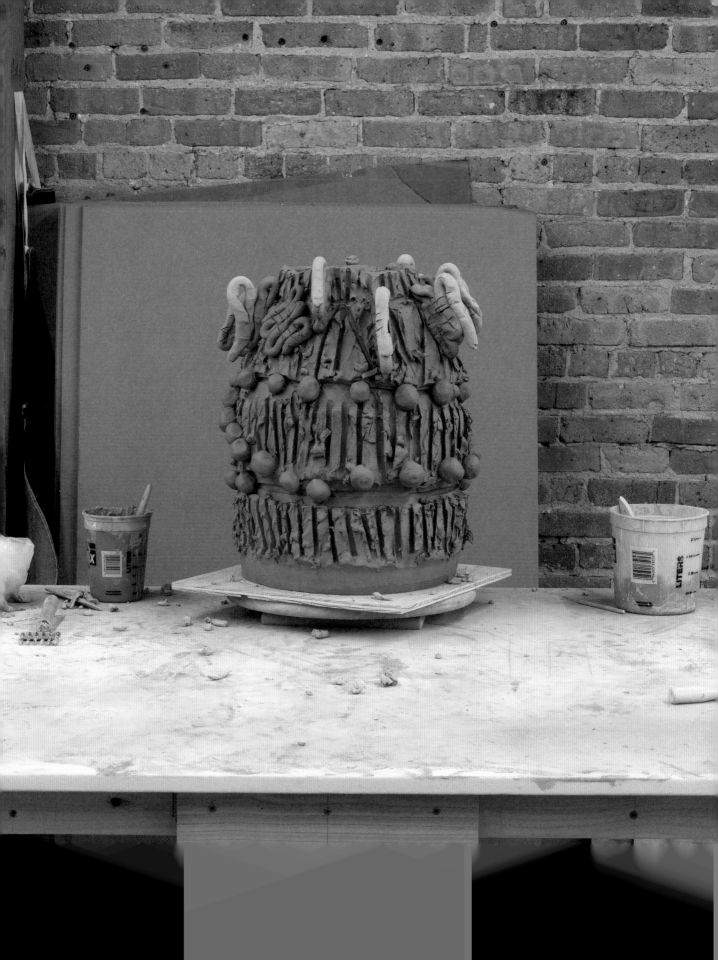

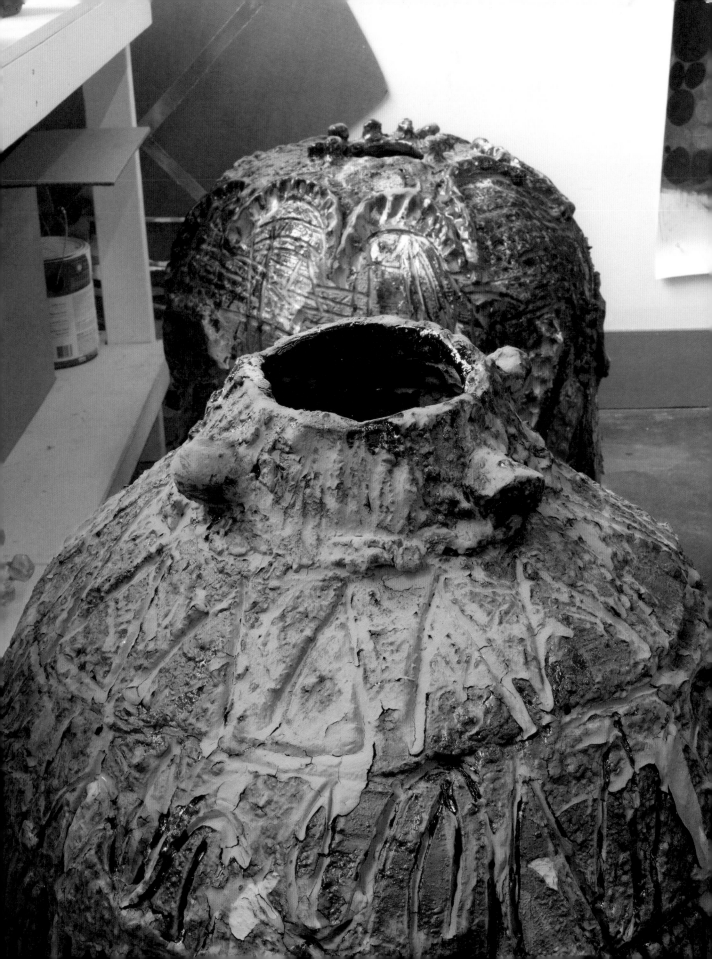

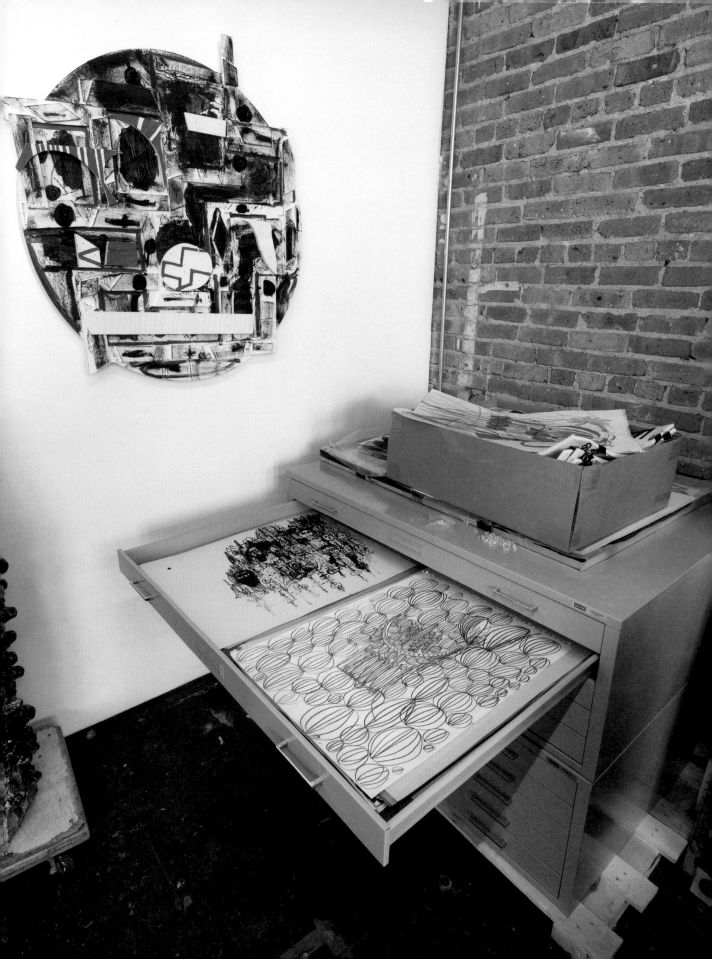

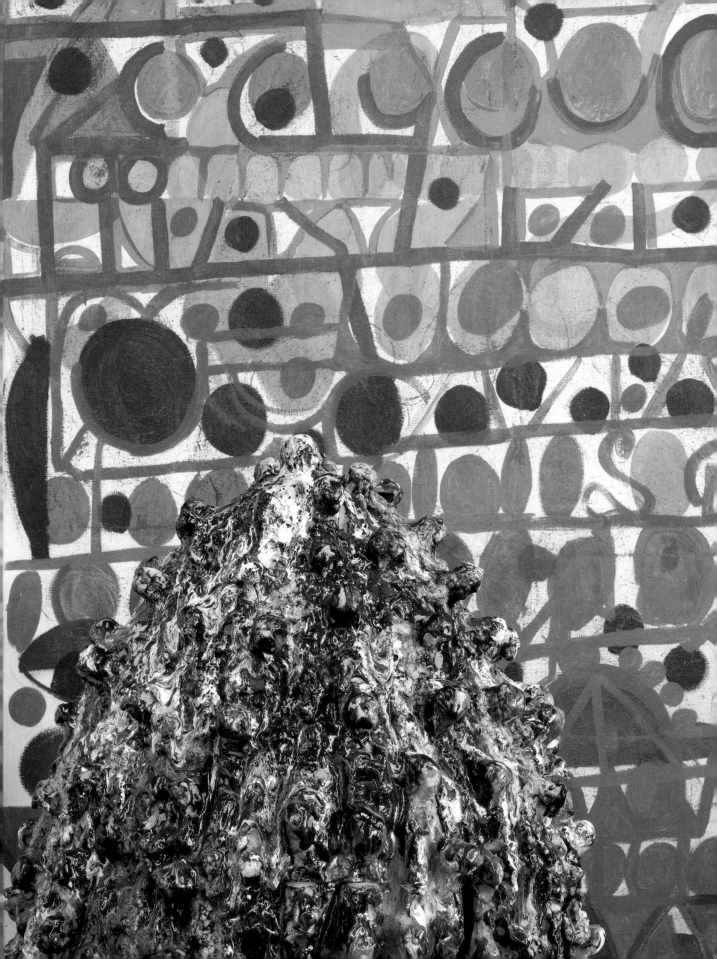

William J. O'Brien

MCA Monographs

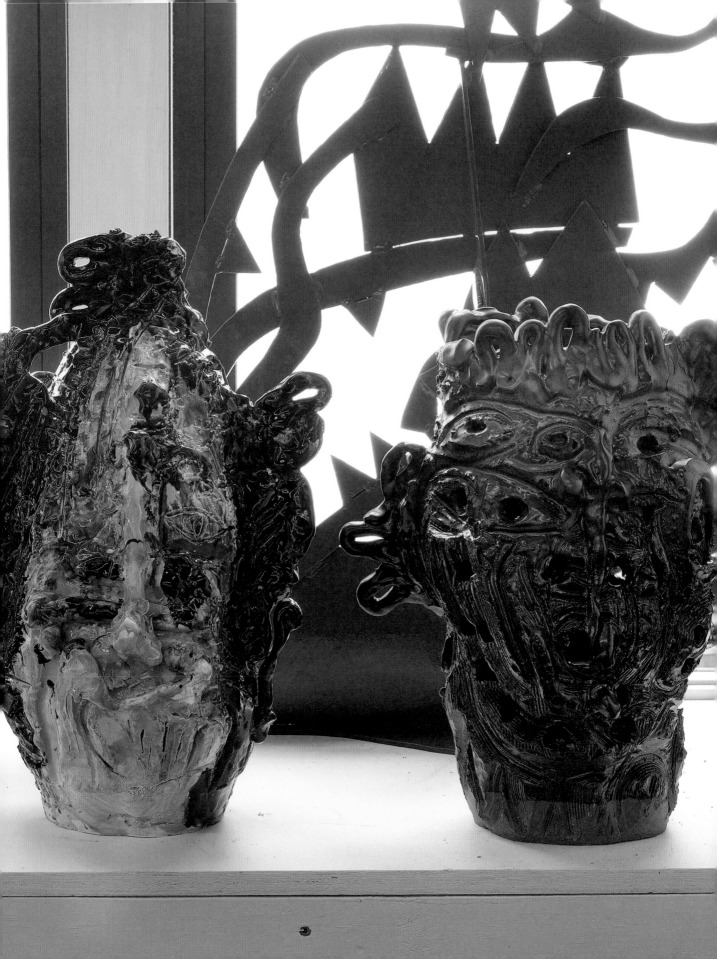

William J. O'Brien

Naomi Beckwith
Museum of Contemporary Art Chicago

ARTBOOK | D.A.P.

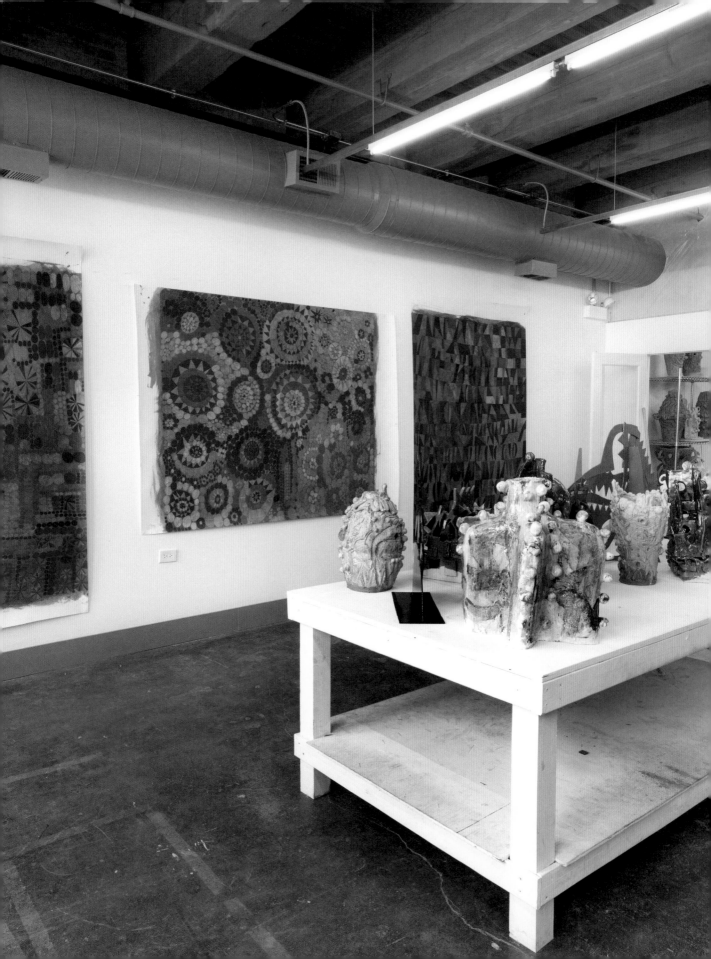

Contents

Director's Foreword

The Museum of Contemporary Art Chicago is proud to present the most comprehensive survey to date of Chicago-based artist William J. O'Brien's multifaceted practice. This exhibition fulfills two crucial aspects of MCA Chicago's mission: to give our local audience access to art that is internationally significant, and to reveal our city's uniquely talented artists to the rest of the world.

O'Brien has steadily gained prominence since 2005, when he received his MFA from the School of the Art Institute of Chicago, where he now teaches, when the MCA featured him in the UBS 12 × 12 series for emerging artists, and since his illuminating 2011 solo exhibition at the Renaissance Society at the University of Chicago. These exhibitions solidified the importance of his work to ongoing conversations about the role of craft and the handmade at a moment of digital profusion.

This exhibition and accompanying publication reflect Marilyn and Larry Fields Curator Naomi Beckwith's keen interest in expanding the critical reception and presentation of O'Brien's work, which have tended to focus on ceramics. In her essay in this volume, she carefully considers the artist's prolific output in drawing and metal sculpture as well as ceramics—and situates what she calls "a practice of inclusivity" in the context of outsider and vernacular art. Trevor Smith, Curator of the Present Tense at the Peabody Essex Museum, explores in his essay the confluence of information overload in the age of the Internet with a revival of the art world's interest in craft. As Smith proposes, it's this very commitment to handmade production that makes O'Brien's sculptures and objects so poignant. For Chicago critic Jason Foumberg, O'Brien's disparate influences and materials launch a series of philosophical riddles, whose myriad threads intertwine and intersect in a creative writing piece. Foumberg's playful yet enigmatic musings, which appear here in the form of kōans—ancient Zen riddles designed to cleanse the psyche—and disquisitions, seek to uncover some of the mysteriousness of O'Brien's artwork.

O'Brien worked closely with Beckwith on the installation of this exhibition, which displays both preexisting works and new pieces created for this exhibition in a way that is sensitive to the MCA's site and context. Collaboration is essential for O'Brien's art, especially when one considers how labor-intensive metal and ceramic production can be. O'Brien carried the same spirit of collaboration from the studio to the MCA, and the exhibition is stronger for it.

This catalogue for *William J. O'Brien* is the first substantial treatment of the artist's work and part of our ongoing Monograph series copublished by D.A.P. At the MCA, support for the exhibition and

catalogue have been generously provided by the Margot and W. George Greig Ascendant Artist Fund. Lead support for the exhibition is also provided by Howard and Donna Stone who have long been supporters of O'Brien's work. Major support is provided by R. H. Defares. We are grateful for additional generous support from Caryn and King Harris, Dirk Denison and David Salkin, Marilyn and Larry Fields, Ashlee and Martin Modahl, Heiji and Brian Black, Martin and Rebecca Eisenberg, Laura de Ferrari and Marshall B. Front, Helyn Goldenberg and Michael Alper, Gary Metzner and Scott Johnson, Melissa Weber and Jay Dandy, Nancy and David Frej, Rodney Lubeznik and Susan D. Goodman, Aviva Samet and James Matanky, Marianne Boesky Gallery, Shane Campbell Gallery, and Louis Vuitton Chicago. We recognize the generosity of our many lenders, listed on p. 102, who also make this exhibition and catalogue possible. We thank American Airlines for their invaluable and ongoing support of the MCA.

Special consideration should be given to O'Brien's steadfast dedication to working with the MCA. After receiving the invitation to collaborate on this exhibition, O'Brien experienced a calamitous studio fire, yet he stayed committed to the exhibition and focused on his work during a time of great personal challenge. We are immensely grateful to him for sharing his work and for trusting us to present it.

Madeleine Grynsztejn
Pritzker Director
Museum of Contemporary Art Chicago

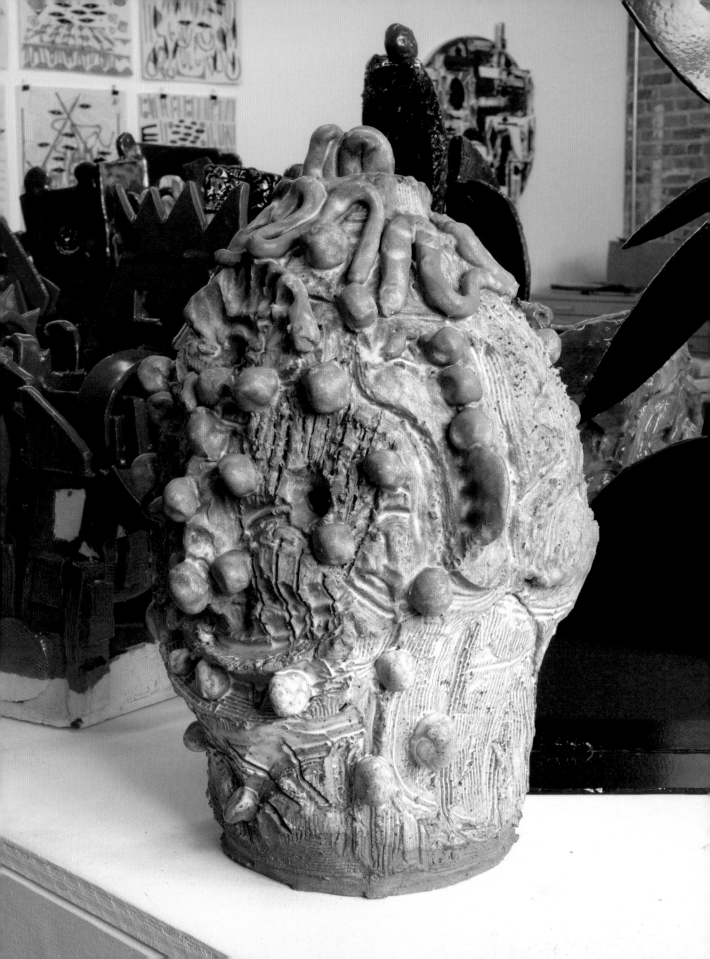

Acknowledgments

As a curator at the Museum of Contemporary Art Chicago, it is a privilege to have access to some of the strongest international art of this generation, yet I glean the greatest satisfaction from knowing masterpieces much closer to home. The first William J. O'Brien works that I—like many people—encountered were his ceramics. I was immediately struck by the breadth of historical, technological, cultural, and design references in these objects, and how seamlessly and skillfully O'Brien combined those references into carefully crafted ceramic sculptures that have the illusion of a hasty formation. One can only imagine my pleasure at discovering O'Brien's numerous other bodies of work—drawings, paintings, metal sculptures, installations— each imbued with intelligence, emotion, and a skilled hand sometimes given over to chance and immediacy.

Several weeks after meeting O'Brien, he and I started talking about an exhibition, only to have those talks cut short by the tragic loss of many of his works in a studio fire. Yet O'Brien remained wonderfully committed to this project, continuing our dialogue about his practice even if he and I could not converse about specific artworks. As O'Brien regrouped and objects reappeared—as seen in the gorgeous photographs of his workspace that grace the opening pages of this volume—we were then able to create an exhibition that presents a sample of his works and conveys a sense of his movement from the inchoate to the ordered, and from darker moods to glistening promises. I am honored to have the privilege of organizing a large-scale exhibition of O'Brien's work. My first thanks go to this artist, whose indomitable spirit and capacity for creating art exceeds any challenge that life may bring.

This project, naturally, is not simply the work of the artist and myself but the initiative of an amazing team at MCA Chicago. The museum's important series featuring ascendant artists, which captures significant inflection points in an artist's career, would not be possible without the vision and leadership of Pritzker Director Madeleine Grynsztejn and James W. Alsdorf Chief Curator Michael Darling. Thanks to them both for trusting me with an exhibition that continues the museum's history of early exposure and continued support of artists.

The success of this project is also dependent upon the inspired and inspiring colleagues who have worked with me to bring *William J. O'Brien* to fruition. Curatorial Assistant Karsten Lund was my constant and indispensable aid in coordinating the exhibition while also helping shape its form and concepts. My thanks to interns Lina Kavaliunas, Gan Uyeda, and Katie Waddell for their invaluable research and assistance on the exhibition and this book. I would also like to thank

my colleagues on the curatorial team who were sounding boards for ideas, particularly Manilow Senior Curator Dieter Roelstraete, Curator Lynne Warren, Curator Julie Rodrigues Widholm, and Curatorial Administrative Assistant Alia Walston. Thanks to Director of Convergent Programming Erika Hanner for her guidance in moving all curatorial projects and their attendant programming forward at the MCA. Director of Collections and Exhibitions Anne Breckenridge Barrett shaped logistics around this exhibition and worked with Registrars Meridith Gray and Chris Hightower as well as Senior Preparator Brad Martin to ensure a safe and attractive installation. Exhibitions can only happen because of those who ensure good operational standing for the MCA and its projects, in particular former Deputy Director Janet Alberti and Chief Financial Officer and Deputy Director for Administration Peggy Papaioannou. I thank them along with Director of Development Lisa Key and her team, especially Deputy Director of Development Gwendolyn Perry Davis and Director of Major Gifts Nora Hennessy who took the lead on garnering financial support for this exhibition. Great press preceded this exhibition because of the fantastic work by Director of Media Relations Karla Loring and Manager of Media Relations Elena Grotto who was preceded by Erin Bird. During the run of the exhibition, our audiences are privy to a greater understanding of O'Brien's work because of Beatrice C. Mayer Director of Education Heidi Reitmaier and her team, especially Programmer of Education: Interpretation Susan Musich.

While exhibitions are by nature temporary, this publication will continue to bring O'Brien's work to a wider public. I cannot thank enough the dedicated people with keen eyes and sensitive voices who brought this book to fruition, especially Senior Editor Lisa Meyerowitz, and Editorial Consultants Lauren Weinberg and David Peak. The book has lovely visual content because of the diligent work of Manager of Rights and Images Christia Crook and Rights and Images Assistant Katie Levi. And many thanks to former Senior Designer Alfredo Ruiz and especially to Scott Reinhard at Scott Reinhard Co. for shaping the content into a beautiful object.

In addition to my MCA colleagues, many other people were instrumental in bringing this exhibition and publication to life. Among them, I must first thank the prescient and scintillating Trevor Smith, Curator of the Present Tense at the Peabody Essex Museum, and the agile Jason Foumberg, whose contributions to this book were rich, intelligent, and original. Shane and Julie Campbell were crucial to building early and deep support for O'Brien's work, so I thank them and their colleagues at the Shane Campbell Gallery, especially John

Schmid and Sam Lipp, for helping to locate and catalogue objects. Marianne Boesky was the first to support this book in particular and my thanks to her and her energetic team, especially Veronica Levitt, at the Marianne Boesky Gallery, who also were key in organizing O'Brien's bounteous output and who are wonderfully incapable of saying "No." William Joyce has been an incredible force at O'Brien's studio, providing innumberable kinds of support. Finally, Bill O'Brien enjoys the unbridled support of many in his Chicago community and I thank those who provided financial support for this exhibition and who, along with lenders nationally, trusted the MCA with their incredible O'Brien works.

A thousand thanks to you all,
Naomi Beckwith
Marilyn and Larry Fields Curator

A World
Created

Naomi Beckwith

Plate 1
Untitled (detail), 2010

21

1
Conversation with the artist, March 20, 2013.
All subsequent statements by the artist are
taken from this exchange.

"There was a time," says William J. O'Brien, **"when the content of
my work was coming from outside sources."**[1] Even though this
assessment of his past work is fairly matter-of-fact, any statement at all
about content seems odd for an artist whose body of work, though
remarkably varied, is dominated by abstract forms. The Chicago-based
O'Brien has been working for almost ten years in a broad practice that
moves seamlessly among a range of media: from sculpture and ceramics
to drawing, textiles, and painting. While many of his early works feature
religious iconography and erotic references, during the past five years,
he has tended to focus on colors, forms, and geometric shapes.

Recognized mostly for his ceramics, O'Brien is closely associated
with a "maker" tendency in contemporary art, in which craft aesthetics,
manual labor, and "doing" supersede an approach to making art based
on theory or academics. Upon careful consideration of the totality
of O'Brien's practice, however, one discovers a profound engagement
with the arc of twentieth-century art movements—from Dada to post-
modernism—and an investigation of what cultural and historical
baggage comes with specific art forms, whether figurative or abstract.
While the artist sets up a contrast between his early and recent work in
this essay's opening statement, O'Brien also implies that content re-
mains a crucial part of his oeuvre, though now internal to the art objects.
This shift from external to internal content then leads to questions:
What does it mean for abstraction to contain content? How do formal
qualities, such as shape, material, and color, hold meaning? In
this essay, I explore these questions by examining O'Brien's artworks—
specifically his drawings, ceramics, and metal sculptures—all of which
the artist produces with ease while demonstrating an intense physicality.

I. Drawings

No matter the medium, almost all of O'Brien's objects are remarkably
kinetic and bear the marks of his hand. The drawings, in particular,
contain many differing shapes and lines, yet all of the works on paper
share a distinctive style: a dense, allover application of myriad vivid
candy colors, unbounded by the edge of the paper. The simplest small oil
pastel and ink drawings, also known as process drawings, tend to
depict broadly circular forms loosely organized in a pattern, or even a
crude human figure, with expressive lines drawn or even scribbled over
them (plate 1). The larger pastel drawings—often on paper greater
in size than O'Brien's body—are each a palimpsest of spontaneous and
continuous lines that amass into a dense soup of intersecting colors.
Most colored-pencil drawings are tight expanses of shape, line, and color.
O'Brien often builds the drawings up from repeated shapes that cohere

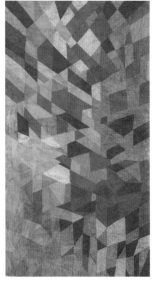

Plate 2
Untitled, 2012

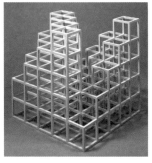

Figure 1
Sol LeWitt, *Cube Structure Based on Five Modules #75*, 1971/1977. Painted wood; 24 ⅛ × 24 ⅛ × 24 ⅛ in. (61.3 × 61.3 × 61.3 cm). Collection Museum of Contemporary Art Chicago, gift of Roger and Neil Barrett, 1994.22.

Figure 2
Sol LeWitt, *Irregular Grid*, 2001. Gouache on paper; 29 ½ × 22 ½ in. (74.9 x 57.2 cm). Private collection.

into loose patterns. Some of these patterns are psychedelic explosions of concentric circles in the shapes of mandalas or flora (plate 4). The more angular drawings are tessellations of rhomboid shapes, which simultaneously convey a sense of depth and a flattened, frontal perspective. In other words, the drawings suggest rhythmic movements and imply a three-dimensional space without being fully architectonic (plate 2). As O'Brien's works on paper move away from exactitude toward a free-form expressionism, they enact a tension between self-discipline and spontaneity.

That control is evident in some of the drawings' overall sense of direction and movement, giving some structure to the shapes and colors, and creating depth within the scene. The legacy of O'Brien's experience as a graphic designer—his occupation between art degrees—is his tendency to organize shapes and patterns on a plane by subdividing the page into sections, usually on a graph or grid. While his graphic design background may have given him a sense of color, shape, and movement, his drawings also often imply a depth of field, figuring three dimensions onto a flat surface. The process sounds like the Greenbergian narrative of the logic of modernist painting, but may have more to do with an architect's or a designer's sense of space derived from op art or artist Sol LeWitt (American, 1928–2007), who is most famous for his gridded structures and geometric and architectonic drawings.

LeWitt, significantly, also had experience as a commercial graphic designer, including a stint for architect I. M. Pei in the 1950s. In LeWitt's sculptural works, one sees an isometric logic at play in which the shape of the work seems to shift with the viewer's perspective. The practice mirrors the artist's desire to physically encapsulate multiple perspectival drawings in one object (figure 1). LeWitt is less well known for his series of gouache drawings, in which he often practiced an irregular geometry, creating lines and shapes that both follow and break a geometric logic. The lines look expressive but are carefully controlled by an underlying organization. LeWitt's *Irregular Grid* (2001) (figure 2) stands as a model for O'Brien, who became interested in the grid, like LeWitt, through graphic design.

O'Brien departs from LeWitt, however, as he seeks other organizing factors that function both with and against the grid. He starts his drawings by creating a substructure that organizes the visible, finished image or objects—a structure based more on gesture than form. One of the many methods the artist employs to create an underlying structure for his drawings involves executing a frottage drawing of an object's surface, an impression that guides the pattern of the overdrawing.

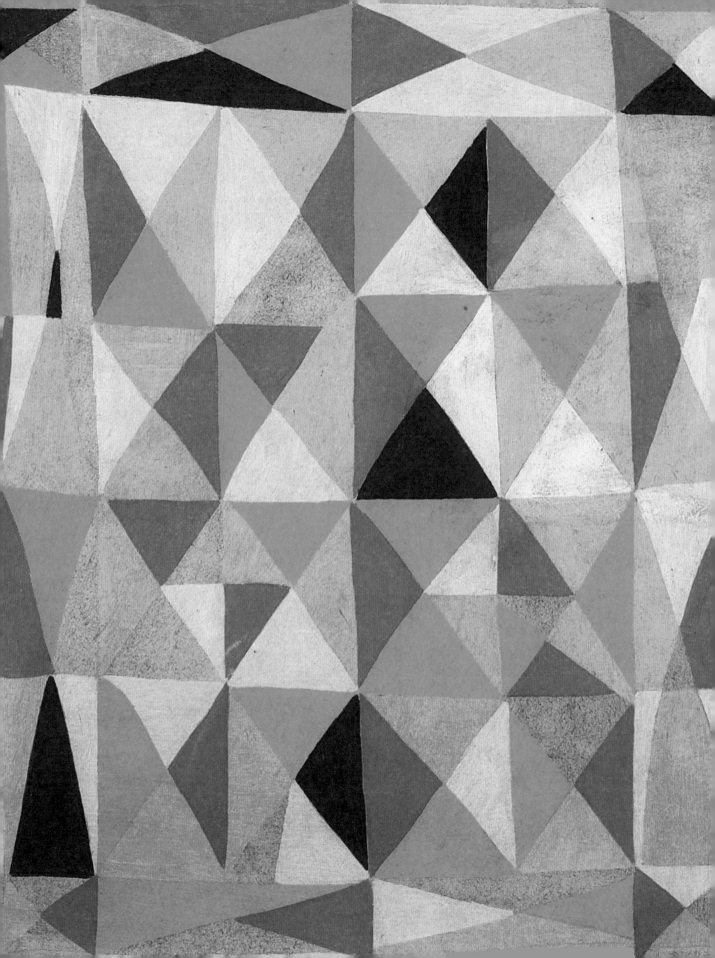

Plate 4
Untitled, 2007

A World Created

25

2

Jacques Lacan (1901–1981) was a French psychoanalyst who, among many other significant contributions to the field, was the first to apply poststructural linguistic models to theories of the unconscious. Structuralism understands that language could be subdivided into two distinct parts: the concrete word/speech and the concept that language attempts to convey. Yet, according to poststructuralism, the relationship between these two components constantly shifts depending on context, the speaker, and the listener, thus there is never a fixed meaning assigned to any word. Lacan argued that, similarly, the human mind is always split between conscious thinking and unconscious drives that motivate conscious thinking, though those drives can never be fully understood. For an introduction to Lacan, his theories, and their impact, see Sean Homer's *Jacques Lacan* (London: Routledge, 2005).

3

Hans Prinzhorn, *Artistry of the Mentally Ill: A Contribution to the Psychology and Psychopathology of Configuration*, trans. Eric von Brockdorff (Heidelberg, Berlin: Springer-Verlag, 1972), 12.

Another method is to create a free-form underdrawing whose lines and shape guide the visible drawing. The relationship is not at all visible or apparent: O'Brien calls the underdrawings "a hidden language" whose relationship to the finished work is "more linguistic than architectural."

The gestural and linguistic analogies are significant because they hint at a nonstructural relationship between the underside and overside, visible and invisible, interior and exterior, the repressed and the expressed. Jacques Lacan was the first to propose that the human unconscious is structured like a language, and that the unconscious structure can only be accessed via what is consciously expressed or spoken.[2] O'Brien thinks of the drawings as maps of a psychology.

O'Brien is far from the first artist to express an interest in the relationship between the unconscious and the art object. This connection was the basis of Hans Prinzhorn's influential *Artistry of the Mentally Ill*, first published in 1922, in which the German psychiatrist argued that an artwork's highest aesthetic value should not be measured in terms of academic values and ideas of "genius" but according to the work's ability to "actualize the psyche."[3] Prinzhorn's publication championed the nonintellectual work of his mental patients and introduced the new field of what is now called outsider art. Prinzhorn was a major influence on surrealists including André Breton (French, 1896–1966), Paul Klee (Swiss, 1879–1940), and other artists, especially Jean Dubuffet (French, 1901–1985), who—first as an outsider art collector, and then as an artist—conceptualized *art brut* based on a long-standing engagement with Prinzhorn's work. O'Brien's exuberant colors and geometric patterning share an affinity with Dubuffet's spontaneous lines and shapes filled in with color and texture, which, in turn, mimic the automatic drawings of the surrealists.

O'Brien considers drawing the foundation for his work in all other media, calling it the "structure of the house." Here the term *structure* describes an approach to art making that distances his drawings from the historical convention of preparatory sketches. O'Brien's drawings create a structure based on an ongoing experiment in maintaining and relinquishing control, and forgiving oneself when that balance is lost. As the artist succinctly puts it: "Drawing is the easiest medium to fail in." O'Brien also appreciates drawing's ability to reveal a narrative. Though his works are far from illustrative or literary, the narrative metaphor invites viewers to "read" them to uncover their structure, movement, and nonlinear development. Thus, O'Brien reveals that drawing, for him, is far from a purely automatic activity, and these improvisatory works map a generic unconscious rather than his own psyche.

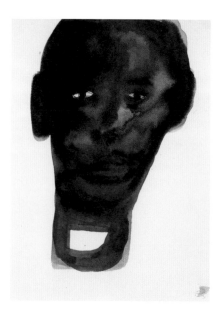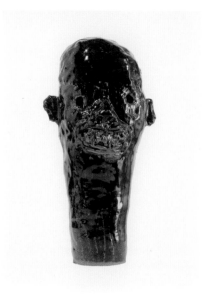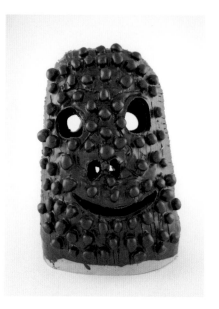

From left: **Plate 5** *Untitled*, 2008;
Plate 6 *Untitled*, 2007; **Plate 7** *Untitled*, 2011

4
Zoë Gray, *Making Is Thinking* (Rotterdam:
Witte de With Center for Contemporary Art,
2011), 7; online exhibition catalogue,
89.234.34.186/wdw. O'Brien was one of the
artists featured in this exhibition.

5
George E. Lewis, *A Power Stronger than
Itself: The AACM and American Experimental
Music* (Chicago and London: University of
Chicago Press, 2008), 96.

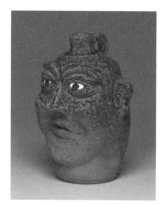

Figure 3
Lanier Meaders, *Face Jug*, 1987.
Glazed low-fired stoneware; 10 in.
(25.4 cm). Milwaukee Art Museum,
gift of Ruth and Robert Vogele
M2000.84.

To think of O'Brien's drawings as improvisation invites comparisons to music, especially post-bebop jazz. The artist's creative process, like that of many jazz musicians, tends to be categorized, even celebrated, as "the avoidance of conscious thinking [with an] emphasis on intuition, instinct and tacit knowledge."[4] As musician and historian George E. Lewis has written, this common sentiment problematically "casts improvisation in general . . . as both lacking in structure and insensitive to historical or formal concerns."[5] O'Brien's work is clearly process-oriented, physically involved and, at times, deeply psychically invested. Yet the challenge is to discuss the breadth of his practice without falling into anti-intellectual neo-surrealism. If there are intellectual and conceptual concerns in O'Brien's practice, the hope is to make apparent the dialogue between O'Brien's work, and modernism and the art that came after it.

II. Sculptures

As O'Brien moves from two- to three-dimensional work, his sculptural objects maintain a sense of bodily immediacy. His ceramic works, constructions, and metal sculptures all bear evidence of heavy manual labor. Unlike traditional sculpture, O'Brien's objects are not carved from or cast in a material such as stone or brass. They are constructed from multiple pieces or materials, which come together like puzzle pieces—via welding, stitching, wrapping, or suturing—and are then sometimes overpainted or glazed.

Ceramic objects are O'Brien's most celebrated works. Though not as central to his practice as drawing, clay has long been an important material for him. O'Brien's undergraduate study focused on ceramics and he has taught the subject at the university level in Chicago. His ceramic oeuvre, a complex practice unto itself, moves widely across several formal vocabularies, encompassing vessels, portraits, masks, and composite constructions of multiple clay pieces that refuse coherence in any conventional sense. Like his drawings, the ceramic works eschew exactitude in favor of an intentionally naive approach. Their *tachiste* effects include calligraphic marks, mottled texturing, scored patterns, and clay balls adhered to their surfaces like pom-poms, and they are often drizzled with vividly colored glazes.

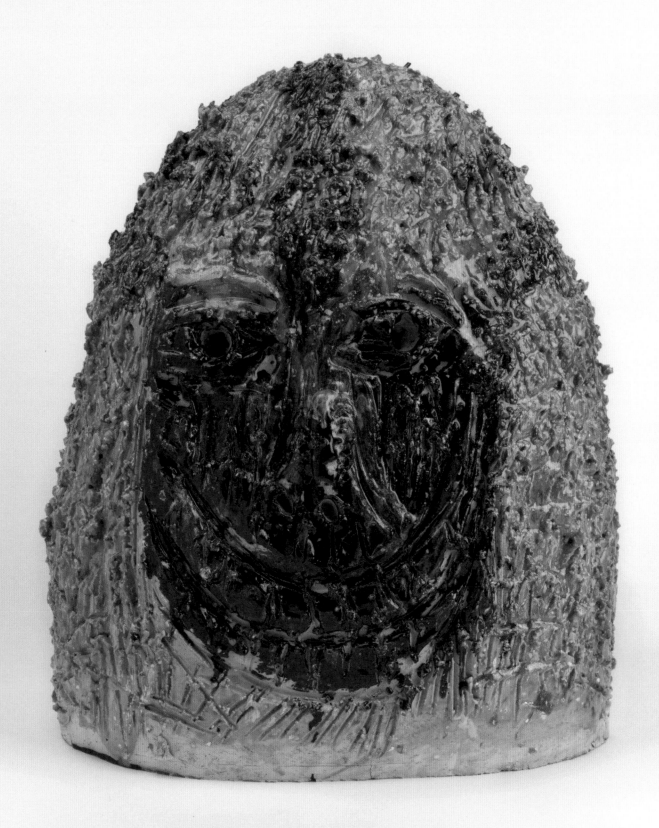

Plate 8 *Untitled*, 2011

28

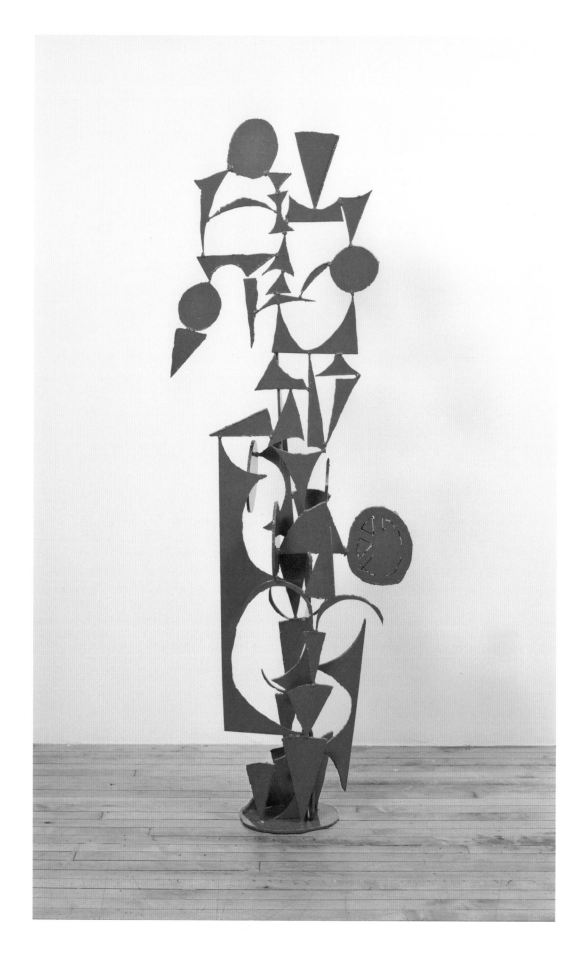

Plate 9
Untitled, 2009

6
Claire Tancons, "An Elective Affinity: David Hammons's *Hidden from View* and *Made in the People's Republic of Harlem*," *Third Text* 19, no. 2 (March 2005): 171.

Figure 4
Mike Kelley, *Craft Morphology Flow Chart*, 1991. Dolls and figures, gelatin silver prints, acrylic on paper, folding banquet tables, and folding card tables; dimensions variable. Collection Museum of Contemporary Art Chicago, gift of Lannan Foundation, 1997.41.

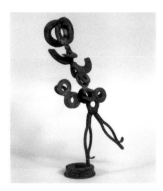

Figure 5
David Smith, *Monday Woman*, c. 1953. Steel and bronze; 21 ½ × 19 × 8 in. (54.6 × 48.3 × 20.3 cm). Private collection.

O'Brien most readily exhibits specific references and influences on his art in his ceramic works (plate 8). From ritual objects of the ancient past, to folk artist George Ohr's (American, 1857–1918) "crazy" pots, to "face jugs" that date back to the antebellum American South (figure 3), O'Brien appropriates many forms from objects once excluded from the realm of high art. The art world's relatively recent interest in craft traditions has given ceramics, as well as other utilitarian, ethnographic, and decorative objects, what art historian Claire Tancons has termed a "semantic upgrade . . . concurrent with the taxonomic shift they underwent, from artifact to art."[6] Yet O'Brien's reference to these works should be framed less as patronizing validations of these ceramic practices as fine art, and more as a conscientious decision to rehearse non-art traditions in his own art practice. These rehearsals acknowledge alternate aesthetic models operating in the social world that might wield as much influence as academically validated forms. We see this principle at work in Mike Kelley's (American, 1954–2012) *Craft Morphology Flow Chart* (1991) in which cheap, everyday objects are systematically displayed in a classic museological order (figure 4). While the installation seems to be a tongue-in-cheek take on museological organization and display, it also underscores the way in which class and economic value become conflated with, and in turn assign, aesthetic value.

As O'Brien moves into other sculptural forms, metal—industrial-grade aluminum, to be precise—is his material of choice. Although working in metal necessitates a great amount of energy and labor, O'Brien considers it "more forgiving than ceramics." Metal is harder to manipulate, but it can be melted down and reformed, whereas ceramics assume a final and immutable form. While O'Brien's ceramics are all similar in scale, the metal sculptures vary from the size of a human torso to that of a tall, fully upright body. Their overall forms are mostly abstract, although sometimes schematically and vaguely figurative, and made of toothed shapes that never cohere into a solid form. They are generally composed of die-cut pieces that are welded together, which lends them both an air of collage and places them in a direct lineage with cubist constructions (as opposed to a reduced sculpture) or early metal works by David Smith (American, 1906–1965) in his surrealist phase (figure 5).

With the welding process come textured lines and edges, which, as with O'Brien's work in any medium, bear the evidence of the artist's hand. The final constructions often display a sense of rhythm and movement, drawing strong, complex lines in space while creating forms using both the positive metal shapes and the negative space within and around each piece. If the structural logic of the drawings is based on a

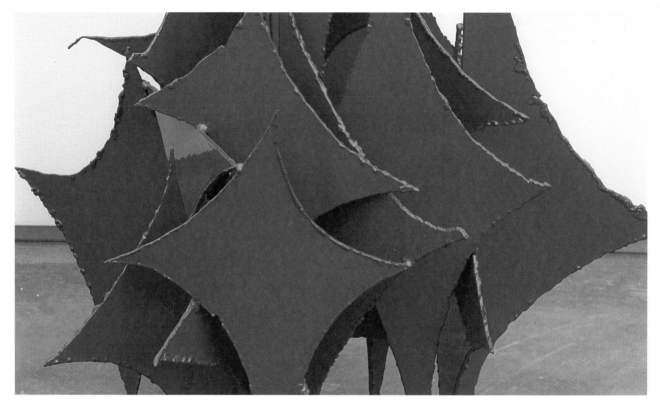

Plate 10 *Untitled* (detail), 2012

7
Hal Foster, Rosalind Krauss, Yves-Alain Bois, and Benjamin H. D. Buchloh, *Art Since 1900: Modernism, Antimodernism, Postmodernism, vol. 2, 1945 to the Present* (New York: Thames and Hudson, 2004), 493.

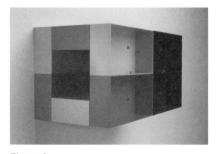

Figure 6
Donald Judd, *Untitled*, 1985. Enamel on aluminum; 11 7/8 × 23 5/8 × 11 3/4 in. (30.2 × 60 × 9.8 cm).

relationship of an invisible interior framework to a visible exterior image, then most of the metal works physically embody that relationship of interiority to exteriority. A sleek powder coating smooths over their surfaces, but not necessarily their rough, welded edges (plate 10). Above all, each sculpture becomes a monochromatic painting-as-construction (or vice versa), evenly coated in the sheen of industrially produced colors borrowed from the same palette employed in O'Brien's drawings.

"That Minimalist art bridges between painting and sculpture, indeed, that it necessarily erases the distinction between painting and sculpture, was the message of Donald Judd's [American, 1928–1994] article in the 1965 *Arts Yearbook*," reads the "1965" entry in *Art Since 1900*.[7] And in Judd's work, we find the closest precedent for O'Brien's metal sculptures (figure 6). First, both establish an inextricable relationship between painting and sculpture (or, more specifically for O'Brien, drawing and sculpture); second, there is a turn to industrial processes and industrial materials—aluminum, commercial paints—for the making of art; and, finally, both Judd and O'Brien articulate a shifting relationship between positive and negative space in the construction of the object and according to the perspective of the viewer. Even with these comparisons, Judd's and O'Brien's works evince important distinctions, both formally and conceptually, which will soon become apparent.

III. Collaboration
O'Brien's two- and three-dimensional works are distinguished by a key factor: his drawings are traditional studio objects made by a single hand, while his sculptures necessitate a community practice. The ceramic works require a kiln and the assistance of others, and the metal works require a workshop and the expertise of die-cutting, welding, and powder-coating specialists. O'Brien states that he maintains relationships with community art centers as part of his work. These

8

Jolly was a ceramicist, educator, and activist in the Chicago arts community, and a cofounder of the women's art collective Sapphire and Crystals. She and O'Brien taught ceramics at Chicago State University at the same time.

relationships are not separate from a private/studio practice. Instead, O'Brien's participation in these communities is an essential part of his artistic production.

Herein lies an important ethical stance: The way O'Brien inhabits the world as an artist is as constitutive to the physical being of his artworks as their materials, forms, and gestures. Both objects and lived processes make up his body of work. O'Brien credits a former colleague, the late Marva Lee Pitchford Jolly (American, 1937–2012), with helping him articulate this idea, though it is probably more of an instinctual philosophy.[8] Jolly "had an admirable way of bridging art and life, bridging the political/cultural self with the artistic self. The work didn't have to be radically political but had to reflect, in a way, how you lived. There was an acceptance and openness to being genuine to your history and psychology—and letting objects reflect that." If Jolly's life and work provide one model of inhabiting the role of an artist as a community-builder, O'Brien exercises another model at Chicago's Lillstreet Art Center, where he enjoys creating work in an egalitarian setting with professional and amateur artists. Although O'Brien has clearly mastered the ceramic medium—while still creating works that physically replicate the look of nonmastery—he is interested in a nonhierarchical exchange with others working in the medium, no matter how amateur. O'Brien has also worked with artists with developmental disabilities, collaborating with Creativity Explored in San Francisco, a center designed to allow its participants to take part in the contemporary art economy. Even when teaching, O'Brien says he works *with* students, rather than teaching art *to* them. All of these examples instill in O'Brien's work a performative element in which the objects are the sum of material and collaborative efforts.

Collaborative labor can be seen inscribed in O'Brien's three-dimensional work and the artist's hand is manifest in every object. These qualities ally O'Brien to artists who contend that any artwork that blatantly exposes the artist's hand cannot be separated from the subjectivity of that artist. Feminist artists and theorists have best articulated this notion, especially in light of performance works such as Carolee Schneemann's (American, b. 1939) *Up To and Including Her Limits* (1973–76) (figure 7), or Shigeko Kubota's (Japanese, b. 1937) *Vagina Painting* (1965). These works demonstrate how even an abstract or gestural mark is never a neutral or purely formal or aesthetic device, and how every mark calls attention to its maker's subjecthood.

While O'Brien's ethical approach to art making stems from performative models, such as those represented by the Schneemann and Kubota works, he never literally performs as an art practice. Instead, he

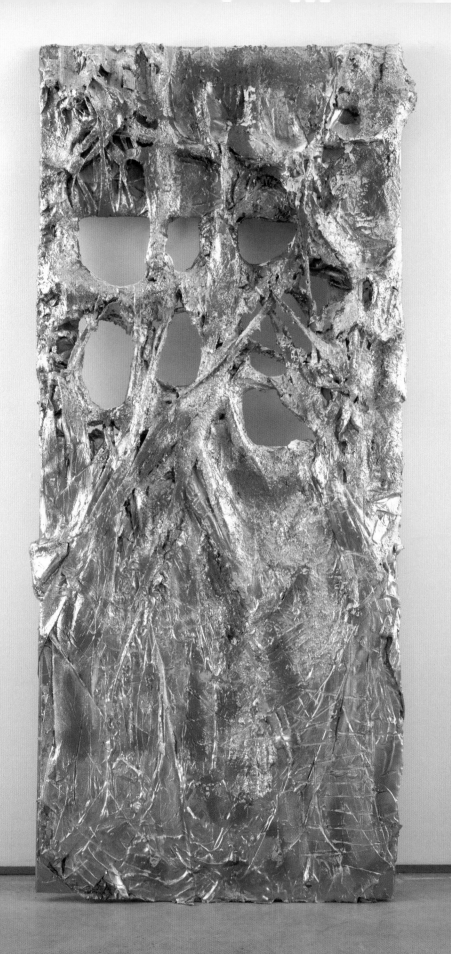

Plate 11
Untitled, 2008

A World Created

33

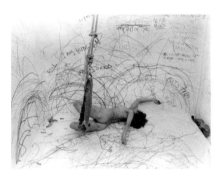

Figure 7
Carolee Schneemann, *Up to and Including Her Limits*, 1973–76. Performance at the Kitchen, New York.

9
Michael Fried decried minimalism's bodily pretenses, which pull the art object into the realm of theater. Michael Fried, "Art and Objecthood," *Artforum* 5, no. 10 (1967), 12–23.

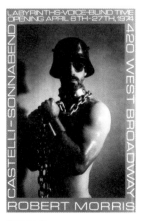

Figure 8
Robert Morris, *Untitled*, 1974 (poster for Voice). Offset lithograph on paper; 36 ¾ × 23 ⅞ × in. (93.4 × 60.6 cm).

seems to limn a dialogue between these performative notions and the objecthood gestalt theory posited by minimalism. If O'Brien's work is such a departure from minimalism, why does he engage with its terms in the first place? The answer is that minimalism became the first art movement to consciously shift away from modernism's idea of the autonomous art object. The minimalists rejected the notion that a work of art is an ahistorical, decontextualized object, created purely for visual and aesthetic contemplation. They understood that an object exists in a real space and time, and that these factors affect how an artwork is perceived: Even light levels and the movement of the sun can alter the object's texture or color. Despite all of minimalism's industrial techniques and disregard for "the hand," its artists shared a concern for the perceiving body of the viewer in the gallery or museum. This "new" viewer was no longer static in the gallery space, staring at a work and contemplating it in a purely cerebral form of aesthetic intake. The minimalists imagined a body whose view of, say, a LeWitt structure would change as the body moved around the object, or, in the case of Carl Andre (American, b. 1935), as a body trampled the work underfoot. It is at this moment in art history that an artwork could be "understood" as more than the sum of its material and labor, and could include a set of conditions and actions, extant to the artist's intent, in its making.[9]

Minimalism's bodily awareness only extended to the viewer and rarely reflected back onto the body of the artist, with the exception, perhaps, of the work of Robert Morris (American, b. 1931). While Morris fully participated in minimalism's gestalt exercises, creating objects that viewers sit on, slide down, and—on at least one occasion—destroy, he also created a series of works in which he interrogated the very conditions of art making, implicating himself and his body as integral to the object's history. *Box with the Sound of Its Own Making* (1961) laid bare art making as a basic form of labor; the *I-Box* (1962) almost anticipated the feminist critique that the object is informed by its artist. In his sensationalist poster for his 1974 exhibition at Castelli and Sonnabend Galleries (figure 8), Morris appears as a beefcake, "naked to the waist, wearing only a German Army helmet (Nazi vintage), mirrored aviator glasses, steel manacles and a spiked collar."[10] What comes across as tongue-in-cheek, and even homoerotic, exposes a heterosexual machismo underneath the industrial aesthetic of the minimalist movement.[11]

There is a second issue with minimalism's turn toward the viewer. While the movement engendered a presumably generous, performative relationship with the viewer, this relationship depended on the pretense of universalist claims. Minimalist objects naively elided any form of

10

Roberta Smith, "Art or Ad or What? It Caused a Lot of Fuss," *New York Times*, July 24, 2009. The Morris poster was a possible inspiration for Lynda Benglis's (American, b. 1941) equally infamous *Artforum* ad of the same year. As the *Lynda Benglis/Robert Morris, 1973–1974* exhibition of the summer of 2009 at Susan Inglett Gallery illustrated, Benglis and Morris were engaged in a loose collaboration in video and images, and Morris's poster might have responded to a set of exchanges between the two artists.

11

Art historian Anna C. Chave argues that while minimalism may be celebrated for a break with the conventions of modernism, it left intact many modernist assumptions about the traditional function of sculpture, including masculinist tendencies toward strength and power, as well as preserving social structures of privilege, patronage, and nepotism among its artists and their supporters. In her scathing view, minimalist artists intentionally enacted a visual, psychic, and at times, literal violence onto their audiences. In Chave's discussion of Morris's Castelli and Sonnabend Galleries poster, the image is not a self-reflexive parody but a means of "equating the force of art with corporeal force, where what prevails or dominates is generally the greatest violence. (134)" Anna Chave, "Minimalism and the Rhetoric of Power," in Holliday T. Day, ed., *Power: Its Myths and Mores in American Art: 1961–1991* (Indianapolis: Indianapolis Museum of Art, 1991), 116–39.

12

Ibid., 139.

13

Brian Wallis, "Power, Gender, and Abstraction," in Day, *Power*. 102.

difference among the viewing subjects, and this elision unwittingly replicated the high modernist presumptions of *the viewer*—that any body is interchangeable for another—rather than acknowledging the possibility of a *multitude* of different viewers.

What happens if a viewer's terms of aesthetic engagement don't jibe well with cubes? What happens if the way you inhabit your body involves a different set of movements and postures from the majority of viewing subjects? O'Brien's work engages with the minimalist aesthetic at a moment when the body is implied yet problematically undifferentiated at the same time. O'Brien's investigation confronts minimalism's tropes head-on yet intentionally avoids any art practices that attempt to figure and represent those "differentiated" bodies. These representational practices are now associated with the "identity politics" vein of postmodernism, a practice that itself easily slips into a mise-en-scène of perpetual differentiation. O'Brien's work, however, articulates the perceptual confusion engendered by the moment when one is simultaneously and paradoxically called out by a minimalist artwork yet unrecognized. As a result, viewers find themselves in a stunted dialogue—one side does all the talking—in which "Minimalism's denial of subjectivity acts to distance and isolate viewers, rather than integrate them into the cultural . . . system."[12]

O'Brien is thus in a double bind: he is isolated both as a viewer and as a maker. Perhaps attempting to illustrate this, he proposed a thought exercise in one of our conversations, asking me to think about "gay minimalism."

Me: What is gay minimalism?
O'Brien: Well, there you go!

O'Brien's smart way of calling attention to a certain aporia in aesthetic production reinforces curator Brian Wallis's thesis that heteronormative "masculinity has come to be associated with abstraction."[13] There is, of course, the prominent counterexample presented by Félix González-Torres (American, b. Cuba, 1957–1996), the queer artist who appropriated the visual language of minimalism and emphasized its performative aspects in projects about subjective and affective experience (see figures. 9–10). González-Torres notwithstanding, one cannot deny the tendency to ascribe certain aesthetics to certain social groups. While there were plenty of examples to the contrary, it is significant that the gay contemporaries of minimalist artists, such as Jasper Johns (American, b. 1930), Robert Rauschenberg (American, 1925–2008), and Andy Warhol (American, 1928–1987), tended to innovate

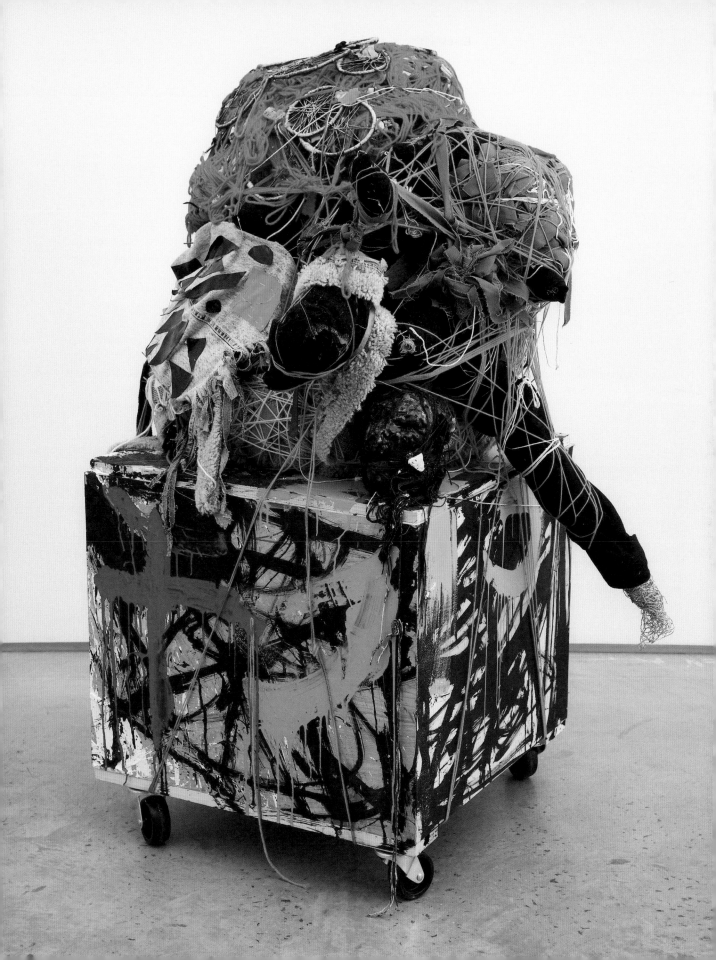

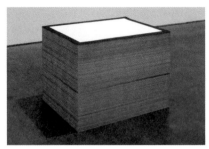

Figure 9
Felix Gonzalez-Torres, *"Untitled" (The End)*,
1990. Print on paper, endless copies. 22 in. at
ideal height × 28 × 22 in. (original paper size).

Figure 10
Donald Judd, *Untitled*, 1988. Wove paper, ink;
17/25, 10 (total); sheet: 23 ½ × 31 ½ in.
(59.69 × 80.01 cm), framed: 31 ½ × 39 ½ ×
1 ½ in. (80.01 × 100.33 × 3.81 cm).

14
In the essay "Notes on Camp," Susan
Sontag argues that the valorization of "bad
taste" was a strategic choice of many gay
men: "Homosexuals have pinned their
integration into society on promoting the
aesthetic sense (52)." In note 54, she argues:
"The experiences of Camp are based on
the great discovery that the sensibility of
high culture has no monopoly upon
refinement. Camp asserts that good taste
is not simply good taste; that there exists,
indeed, a good taste of bad taste." Susan
Sontag, "Notes on Camp," *Partisan Review*
XXXI (Fall 1964): 515–30. Reprinted in
Against Interpretation and Other Essays
(New York: Farrar, Straus Giroux, 1986), 291.

in the nascent pop movement, with all of its associations with life out-
side the gallery system, appropriation from the media, and embrace of
questionable "taste."[14]

IV. Categorical Distinctions

O'Brien has built an art practice in a dialogue with the span of twentieth-
century art movements, hovering at significant points along the
trajectory. Those stops are significant: In the three bodies of works
discussed here, by no means the full extent of his oeuvre, we have seen
the artist engage with that which is often excluded from high or
academic art discourse, whether as an object or as audience. O'Brien
has unwittingly found a link between two movements that bracket
modernism—the *art brut* or outsider art of early modernism, and mini-
malism, which offered a clean break with modernist art conventions.
Both movements devalue the skilled hand of the academically trained
artist though they diverge in their treatment of non-normative, or
different, bodies. Both outsider art and minimalism relate the art object
to difference—on the one hand, by intentionally calling attention to
the non-normative status of the object's maker, and on the other, via a
tacit refusal to recognize differences among the object's viewers.

Difference is not a static status, however. Throughout history,
non-normative categories have both arisen and dissipated, inflecting the
reception of cultural works far beyond the moment of their arising.
Wallis, in his essay on late-modernist minimalism and its modes of mas-
culinity, begins his discussion at the earliest stages of modernism:
"For instance, the defining of madness in the nineteenth century, through
a whole regime of texts and representations, created a situation whereby
insane people were treated differently in all contact with society;
previously such a position had not existed. This capacity to define new
subject positions through the application of such disciplinary
measures also holds the promise that old or oppressive positions can
be challenged or overturned."[15]

Soon after "insane" became a recognizable diagnosis, the art of
the insane burgeoned into an aesthetic category of its own, and the art
produced by psychiatric subjects in the early modern period stood as a
model of avant-garde, anti-academic practice—exemplifying the
rejection of academicism, formal training, and even conscious thought.
Although other art movements have drawn upon a notion of unconscious
creativity, most famously abstract expressionism, O'Brien has distanced
himself from that mode of creation with its macho connotations and
mythologies of freedom. Rather than ally himself with American expres-
sionists—although there are some formal and technical affinities in

15
Wallis, "Power, Gender, and Abstraction,"
100–01.

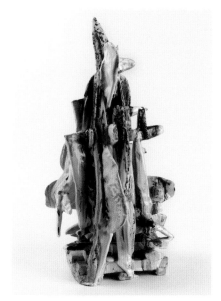

Plate 13
Untitled, 2011

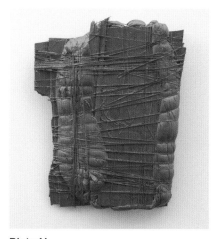

Plate 14
Untitled, 2010

some of the works—O'Brien chooses to return, full circle, to early modern notions of anticerebral, expressionist art, again evidenced by his work with the developmentally disabled.

Similarly, in ceramics, O'Brien incorporates a model of difference by creating artworks whose most immediate references, when apparent, have historically been excluded from the realm of high art—namely ceramic vessels and other utilitarian objects, as well as "ethnographic" and ornamental objects. O'Brien underscores how the relegation of these often anonymous objects to the realm of craft excludes the makers, as well as the objects, from serious participation in the realm of visual art production. Although these forms may exercise some influence on high-art practice and many have been redeemed as "art," the authors of utilitarian and ornamental objects—mostly women and people of color—are rarely acknowledged individually in the history of modern aesthetics.

As the modern period ended in the 1960s, minimalism ushered in the "specific object" in place of the "autonomous art object." Although this important aesthetic shift was a break with modernism, minimalism's expulsion of ornament and decoration, and mimicking of industrial production, became equated with the inhuman. O'Brien's metal sculptures at once take up the formal elements of minimalism—reduction, repetition, modular application of color—and abandon its signature grid, refusing to be contained by its normalizing and flattening boundaries. Instead, his sculptures bear all-too-human welding marks and organize the modular forms in ways that mimic movement and kineticism. They offer the audience a view through and around them, underscoring the interiority of the object and, by implication, the interiority of the viewer (in other words, the things that make each viewer distinct). In O'Brien's work, difference in modular repetition replaces repetitive sameness. The hand replaces the machine; movement replaces immobility.

"Happiness for me is when the body is moving," says O'Brien, citing both the necessity of composing art objects with his body and the idea that art for him is also an emotive process, a path toward emotional fulfillment, which he also describes as a spiritual quest. Art for O'Brien then is both an aesthetic and kinesthetic exercise whose function is not necessarily to produce beauty but to help maintain balance in one's inner life—the art objects then become metaphysical markers whose physical and formal structures evince that important relationship between external art output and internal equilibrium. Just as the metal sculptures create interior and exterior spaces through positive and negative shapes, the ceramics equally exhibit interiority and

Plate 15
Untitled, 2008

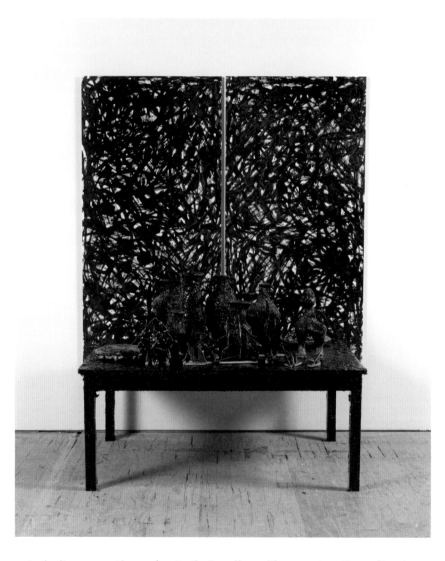

exteriority—sometimes due to their collage-like construction, often by simply being modeled after vessels—and even his drawings depend structurally upon an underside or interior that is invisible.

Thus, the very construction of O'Brien's objects, their rhythmic gestural immediacy and meditative repetition, illustrate their functionality as an exercise in care for oneself and the liberation of the will. The transcendental element of his work avoids notions of the sublime, as well as symbolism and iconography, where the burden of spiritual content generally lies. This is one of O'Brien's major innovations:

to imbue a body of mostly abstract work with a sense of metaphysics without resorting to cliché. The metaphysical content is mostly imparted by his working process—one in which the elements of his objects come together via incantatory bodily gestures.

The repetitive gestures also suture the multiple elements that compose an O'Brien art object. This is best seen in a body of work not yet mentioned in this essay: O'Brien's monochrome paintings, which generally are less paintings per se and more assemblages coated in a thick varnish of one color, or of color and glitter. These assemblages often consist of multiple objects, such as strips of cardboard that are dipped in paint and/or wrapped in string—again in a repetitive, almost mummifying gesture—and then adhered to the canvas. The entire arrangement is then overpainted in a unifying way so that the texture of the objects remains visible, although the types of objects are not always recognizable. The altar-like installation *Untitled* (2008) (plate 15) is a tour de force of this technique, incorporating drawings, ceramics, and found objects in a work that exists as a monochrome yet demonstrates formal and gestural excess. In this, and other similar works, O'Brien absorbs disparate elements into the language of painting, achieving an inclusive, democratic state in which there are no hierarchies of objects or forms. *Untitled* exists somewhere between art object and spiritual site.

Though O'Brien succeeded in creating a democratic artwork he continues to produce at an incredibly fecund pace. Perhaps it's because all of his art objects, no matter how pedestrian or craft-like, become de facto "art" in the space of the museum or gallery. Thus the inclusive gesture that O'Brien enacts in bringing the objects together is negated in their sublimation into the art world, where they are separated from their humble roots. But there is one egalitarian space left where the objects are both art and cathectic objects. "The studio is the place where a world is created," says the artist. In the studio, he can labor under the premise of equal access to objects and a harmonious transformation of all materials. Again, when O'Brien must create work outside his studio, he does so in places where there are no skill barriers and anyone can make any kind of work of art. These modes of working belie an instinctive resistance to modernism's insistence on the autonomous object—one removed from the social world in production and in experience. Thus, although O'Brien's work harkens back to the modernist grid or the unconscious gesture, the terms are decidedly postmodern, rejecting modernism's historical associations with masculine and Eurocentric privilege, whether true or not. In other words, O'Brien's practice of inclusivity produces a democracy every day. ∎

In Lumpen Bits: The Digital Paradoxes of William J. O'Brien

Trevor Smith

Plate 16
Untitled, 2010

41

**What we call the beginning is often the end
And to make an end is to make a beginning.
The end is where we start from.**
—T. S. Eliot, *Four Quartets*

Historically the kinds of practices William J. O'Brien engages in—ceramics, textiles, steel sculpture, pen-and-ink drawings—are associated with resistance, even fierce opposition, to technologies that diminish our relationship to tactile experience, such as the Internet. The unbreakable bond between manual skill and mental dexterity in artisanally based practices has been evocatively described by sociologist Richard Sennett as "the intelligent hand," and there is no mistaking O'Brien's elegantly lumpen ceramics for anything but purposefully handmade.[1] Fully embracing a do-it-yourself vernacular and suggesting almost nothing of the virtual in outward appearance, his work *is* clearly digital in its original sense of pertaining to the fingers. Yet, like many artists today, his work also participates in the flood of unmoored material associations and cultural connections that are a hallmark of contemporary, digital culture.

Writing this essay in the cybernetic embrace of Google, it is instructive to recall that when Sol LeWitt published his "Paragraphs" in the June 1967 issue of *Artforum*, artists and scientists alike were only beginning to grapple with the potential of the information revolution. The term *image bank* had only recently been coined in William S. Burroughs's 1964 book *Nova Express*. Although the word *digit* has long been the connection between fingers and numbers (0–9), the computational derivation of digital that is in everyday use today is not even mentioned. In this context, LeWitt's articulation—that the key difference between the emerging practice of conceptual art and other forms of advanced art of the day was a strict separation between the *conceptual* and *perceptual* aspects of the work—was radical indeed. For him, physical production was a zone of subjectivity that lay between the work's conception and perception, and therefore in need of careful monitoring lest the artist's idea be diluted or obscured:

If the artist wishes to explore his idea thoroughly, then arbitrary or chance decisions would be kept to a minimum, while caprice, taste and other whimsies would be eliminated from the making of the art. The work does not necessarily have to be rejected if it does not look well. Sometimes what is initially thought to be awkward will eventually be visually pleasing.[2]

1
Richard Sennett, *The Craftsman* (New Haven, CT: Yale University Press, 2008), 147.

2
Sol LeWitt, "Paragraphs on Conceptual Art," *Artforum* 5, no. 10 (June 1967), 79. Reprinted in Kristine Stiles and Peter Selz, eds., *Theories and Documents of Contemporary Art: A Sourcebook of Artists' Writings* (Berkeley, Los Angeles, London: University of California Press, 1996), 824.

Plate 17
Windsor, 2012

Even as the distinction between conceptual and more embodied forms of production dramatically blurred over the last fifty years, LeWitt himself increasingly depended on people with intelligent hands to execute his plans faithfully. Working with teams of trained artists and artisans, his instructions relate to his wall drawings and sculpture in the same way that an architect's plan relates to the edifice constructed by the builder.

O'Brien's work is very much in and of his own hand: objects that he himself built, glazed, assembled, painted, and worked. But he is not an outlier. Interest in ceramics and textiles—media typically associated with craft disciplines—has grown in contemporary art discourse alongside and often bound up with the ongoing generative influence of conceptualist practices. Signs of the revival of artisanal consciousness are everywhere—from locavore food and small-batch whiskey to handmade clothing—even if we often access such products via the textureless, virtual realm of our computer screen.

Through the accumulation of materials, constellations of objects, and arrays of tried-and-tested formal possibilities, O'Brien's installations impart the sense of daily physical labor of making things (as seen in plate 18). Unlike a diverse range of artists from Richard Jackson (American, b. 1939) to Dieter Roth (Icelandic, b. Germany, 1930–1998) to Ann Hamilton (American, b. 1956), O'Brien does not fetishize the stains and scars of process. Instead, his work accrues power through acts of accumulation. Roughly hewn, scarified, textured, thickly glazed ceramics are arrayed on tiered plywood platforms. Pieces of steel that appear as if they were offcuts left behind by an unknown modernist sculptor are reconstructed into powder-coated sculptures in works such as *Windsor* (2012) (plate 17). There are many untitled drawings in which the paper surface is divided into haptic recursive geometries that have a range of resonances from Oceanic and African patterning to American abstraction, and automatic drawings from Paul Klee to Joseph Beuys (German, 1921–1986) and Mark Manders (Dutch, b. 1968).

O'Brien's labor is more artisanal than industrial, more *wabi sabi* than precision engineering. Three-dimensional printing technologies or injection molding are not his thing—the basic tools and technology required to produce ceramics and weld steel, to say nothing of pencil and ink, have been with us for a very long time. Clearly he is not one of those artists whom LeWitt described as confusing "new materials with new ideas."[3] O'Brien's work makes clear how new ideas can be expressed with old materials, so in spite of its low-tech appearance, it might be fruitful to consider the ways in which the Internet has dramatically reconfigured our connections to images and information.

3
Ibid., 825.

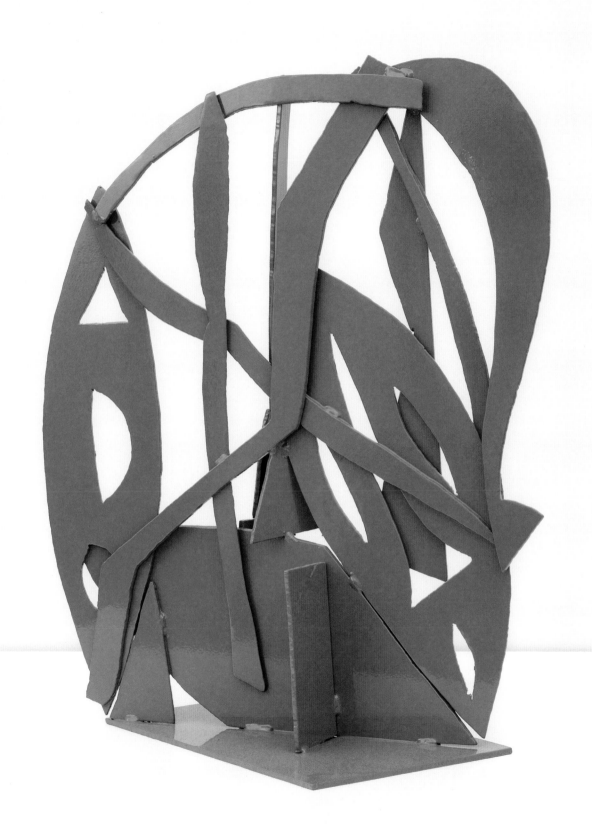

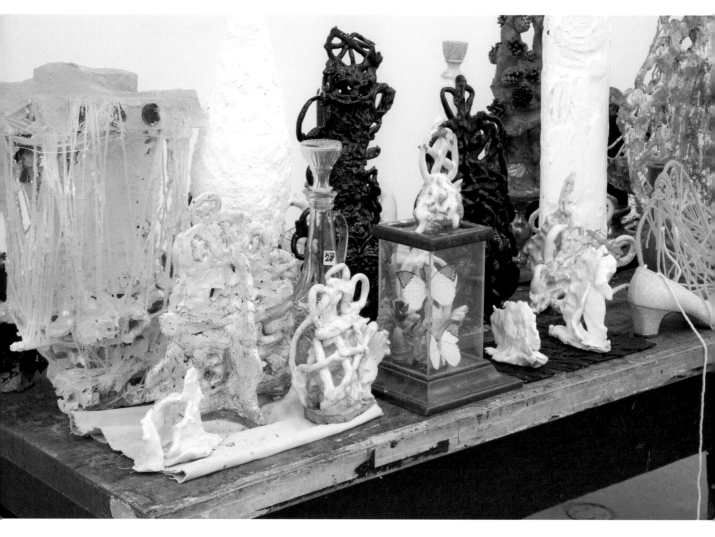

Plate 18
Cinaedus Table, MDCCLXXV, 2007

It has scrambled academic assumptions about cultural hierarchies such as the value of unique objects over reproducible ones, oil paintings over drawings, bronze sculptures over ceramic objects, and high art over popular culture. Cultural practices that are distant in time and space from our own seem to be brought closer and, for better or worse, made available for reimagining in new and unexpected idioms. While O'Brien's arrangements of objects resonate with modernist élan and anthropological wonder, they suggest less an alternative museology than an accumulation in which each variation of size, color, surface, mark, and shape functions as a unique integer in an ever-growing data set. His objects are arranged with studied neutrality—each forms part of a larger constellation in which patterns and connections emerge as the viewer walks around taking in the whole exhibition. Like cultural DNA, O'Brien's objects might be recombined in other arrays, in other rooms, and at other times. Each installation remains but one possibility among many.

4

See Michael Darling, *The Language of Less (Then and Now)* (Chicago: Museum of Contemporary Art Chicago, 2011).

Figure 1

Jason Dodge, *In Lübeck, Germany, Marlies Scholz wove a piece of cloth. She was asked to choose yarn the color of night and equaling the distance (12 km) from the earth to above the weather.* Collection Museum of Contemporary Art Chicago, gift of Mary and Earle Ludgin by exchange, 2011.42.

5

Originally released by the British Council in September 1947 as a set of six 78 rpm records, Eliot's reading has been reissued as "T. S. Eliot Reading *The Waste Land, Four Quartets* and Other Poems," Harper Collins Audio Books, 2005. As of the date of writing, it is available on YouTube at youtube.com/watch?v=Ga8tQrG4ZSw. For the full text, see T. S. Eliot, *The Complete Poems and Plays 1909–1950* (New York: Harcourt, Brace, 1971), 144.

A 2008 work by Jason Dodge (American, b. 1969), recently exhibited at MCA Chicago and now part of the permanent collection, also evocatively suggests this paradox of the handmade being encoded in digital culture: a handwoven purple-blue fabric, carefully folded and tied with string.[4] Its title reads: *In Lübeck, Germany, Marlies Scholz wove a piece of cloth. She was asked to choose yarn the color of night and equaling the distance (12 km) from the earth to above the weather* (figure 1). Just as in classic conceptualism, Dodge's instruction to the weaver existed as a mental image in advance of its physical manifestation as a piece of cloth. Yet, while the instruction to use twelve kilometers of yarn was precise, Dodge's acknowledgment of the weaver's interpretive role moves beyond a typical exercise in conceptualist outsourcing. The quixotic task of interpreting what the color of night might look like depends entirely on the artisan's imagination and skill.

Linking scientific measurement to artisanal production, Dodge's poetic data visualization suggests ways in which artists today weave together disparate images, objects, and cultures into new webs of connection, much like the Internet does. What was once an almost clandestine, hard-won knowledge accessible only to initiates is now available to anybody with a few easy keystrokes. Almost any fragment of material culture that has moved me, no matter how obscure, can be found online. Apia nie bowls from Micronesia: check. Skylights in the Topkapi Palace: check. Mongolian Tus Kiis: check. Search for Cy Twombly's (American, 1928–2011) sculptures or Robert Rauschenberg's *Cardboards*—both of which I first encountered as rumors or rare books that artists had generously shared with me—and you will find images in profusion. Even T. S. Eliot's Anglo-American tenor can be heard incanting his *Four Quartets*:

> **In my beginning is my end.**
> **In succession**
> **Houses rise and fall, crumble,**
> **are extended,**
> **Are removed, destroyed, restored,**
> **or in their place**
> **Is an open field, or a factory,**
> **or a by-pass.**
> **Old stone to new building,**
> **old timber to new fires,**
> **Old fires to ashes, and ashes**
> **to the earth**
> **Which is already flesh, fur and faeces, . . .** [5]

We have quickly become accustomed to this flood of information, but it is instructive to consider how much our relationship to images has changed since the Internet became commonplace. As an art history student, I remember hearing about a drawing by Klee, *Angelus Novus*, which was once in the collection of the literary theorist and philosopher Walter Benjamin. In Benjamin's final major essay, written not long before his suicide on the Spanish border in a failed flight from Nazism, he conjured Klee's image as the angel of history. He described the angel as "turned toward the past," unable to close his wings because the storm of progress has pinned them open. He is irresistibly propelled "into the future to which his back is turned, while the pile of debris before him grows skyward."[6]

6
Walter Benjamin, "Theses on the Philosophy of History," *Illuminations* (New York: Schocken Books, 1969), 257–58.

Knowing it had conjured Benjamin's dramatic vision, I remember wondering what Klee's *Angelus Novus* looked like—at the time, it was easy to find reproductions of Klee's work but almost impossible to find this particular image. When I eventually did see it, I remember being shocked at how anodyne Klee's artwork appeared in contrast to Benjamin's powerful allegory. Measuring only 12 ½ by 9 ½ inches, Klee's "new angel" is sketched in diagrammatic geometric lines and whorls on a paper stained with a mottled brown wash. That wash deepens toward the edges of the page, and where the wings, skirt, legs, and hair of the angel appear. Did Klee lay the india ink down on a preexisting stain, or did he deepen the wash to give weight to wings, skirt, legs, and hair? Reproductions are no help for this kind of detail. Nonetheless, when I simply type "Angelus Novus" into Google today, my screen fills with Klee's angels, including two tattoos: one a copy of the drawing, the other Benjamin's quote indelibly printed on an anonymous forearm (figure 2).

Paul Valéry, the French poet and essayist who was the subject of a great deal of Eliot's critical attention, is cited by Benjamin in his renowned 1936 essay "The Work of Art in the Age of Mechanical Reproduction" for predicting how, in the future, images will be so close to hand that they might be conjured and dismissed at will:

Just as water, gas, and electricity are brought into our houses from far off to satisfy our needs in response to a minimal effort, so we shall be supplied with visual or auditory images, which will appear and disappear at a simple movement of the hand, hardly more than a sign.[7]

7
Walter Benjamin, "The Work of Art in the Age of Mechanical Reproduction," ibid., 219. Original quote from Paul Valéry, "The Conquest of Ubiquity," *The Collected Works of Paul Valéry*, *Aesthetics*, ed. Jackson Matthews, trans. Ralph Manheim (New York: Pantheon Books, 1964), 226.

Today, images are far more likely to be encountered through the simple hand gestures (which Apple has tried to patent) of tapping, scrolling, pinching, and swiping than by engaging with traditional art

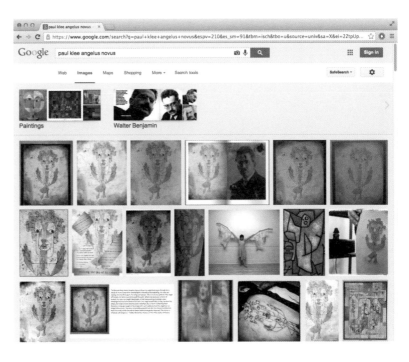

Figure 2
Screenshot of a Google search for "Paul Klee angelus novus," October 24, 2013.

8
Vilém Flusser, "The Non-Thing 1," in *The Shape of Things: A Philosophy of Design* (London: Reaktion Books, 1999), 89.

practices. Philosopher Vilém Flusser has described how, in this culture driven by access to information, our intelligent hands have atrophied. They are reduced to the tips of our fingers, which are used "to tap on keys so as to play with symbols. The new human being is not a man of action anymore but a player: *homo ludens* as opposed to *homo faber*."[8] For O'Brien and artists like him who are clearly invested in the labor-intensive process of making unique objects by hand, one wonders if digital culture is a storm of progress à la Benjamin, piling up image traces and information wreckage out of which they might construct their works. Or, to borrow from Eliot, is it a kind of binary compost in which their analog culture continues to renew itself in the present tense?

O'Brien gives the very kinds of materials that would normally wind up in the studio garbage presence and function as art. He assembles sculptures from pieces of plywood, string, plaster, tape, and cloth. He appliqués scraps of red felt onto canvas in homage to and/or parody of the great vernacular tradition of red and white quilts. And there is the visceral impression that O'Brien's practice sometimes emerges from the wreckage or byproducts of other kinds of manufacturing processes: the echoing circular shapes in his untitled red powder-coated steel totems that were exhibited at Marianne Boesky Gallery in 2013, for instance, appear to be built using discarded steel from a tool and die factory.

In this regard, O'Brien's work might be seen as a continuation of the ongoing revival of constructed sculpture, surveyed in the exhibition *Unmonumental* at New York's New Museum in 2007. His use of discarded materials, however, plays as much with the process-oriented legacies of deconstruction and ecology as it does with the surrealist and

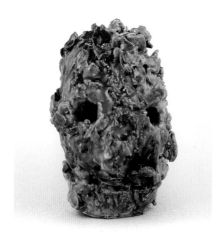

Plate 19
Untitled, 2007

constructivist legacies of conjoining dissimilar images and materials to dramatic effect. Cultural practices are entirely lumpen on the web, but O'Brien's work takes these uprooted and vagabond forms and reconstructs them into new constellations of affect. Perhaps we might coin the term *reconstructivist* to describe this technique, where anthropomorphized forms jostle with abstract shapes, and thrift-store aesthetics play out against high art references. In ways that are materially antithetical but conceptually analogous to frictionless cyberspace, radically disparate reference points collide in the rough hand-built surfaces of his ceramics.

Faces appear in a great many works: some incised, others shaped, while still others only suggested abstractly. There are ovoid forms that suggest Dan masks, children's drawings, or Lucio Fontana's (Italian, b. Argentina, 1899–1968) paintings in their concrete and diagrammatic nature. We see a Giacometti (Swiss, 1901–1966) nose here, or a Paul McCarthy–esque (American, b. 1945) caricature there. *Blueberry Head* (2010) suggests a mash-up of an antebellum face jug with a lingam imagined by a Lobi potter. In the end, no specific reference seems more important than their accumulation, the fact that they can be combined and recombined at will. These arrays are a kind of analog search engine—a catalogue of possible gestures that opens the door to webs of diverse associations and cultural implications.

This logic of accrual—along with the recursive structures visible in his drawings and textiles—suggest that a certain *horror vacui* haunts O'Brien's work. Yet the opposite might be said to be true. The challenge that artists of O'Brien's generation face is not based on a fear of *empty* space but a need to *create space* out of oceanic digital accumulations. It is a struggle characterized precisely by the unfathomable range of options and information in digital culture relative to limited human agency. It is in this sense that his commitment to handmade production is so poignant, far more than a simple revival of craft practices or artisanal traditions. Even O'Brien's largest sculptures and objects are scaled to his intelligent hands. His installations do not offer spectacle but instantiate a demonstration of his own modest agency—a proposal for integrating the analog and the digital, machine data and personal experience. ∎

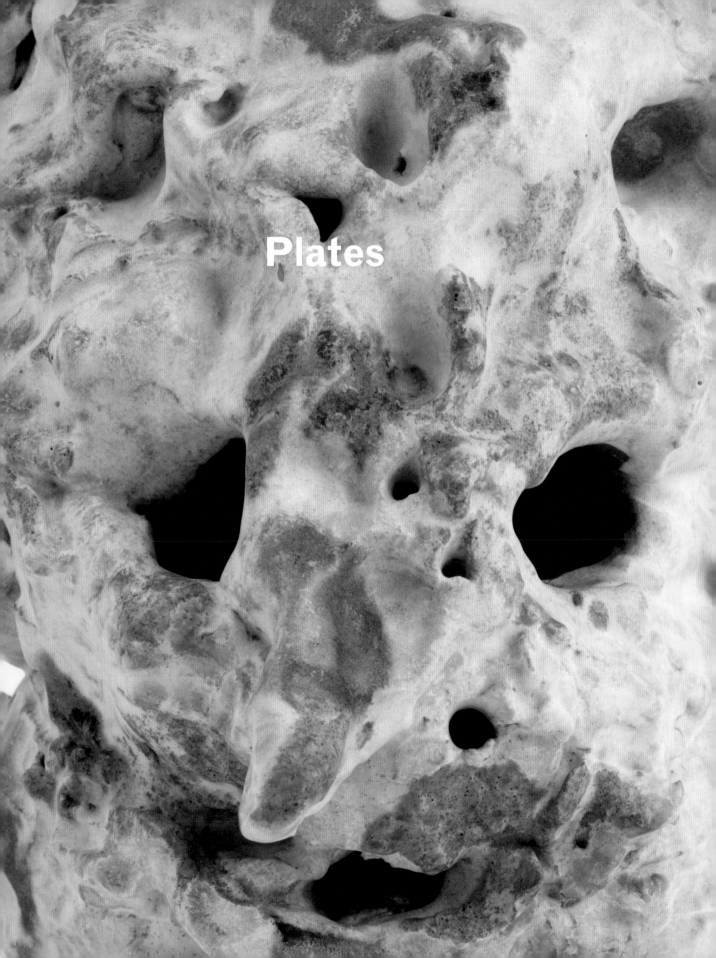

Plates

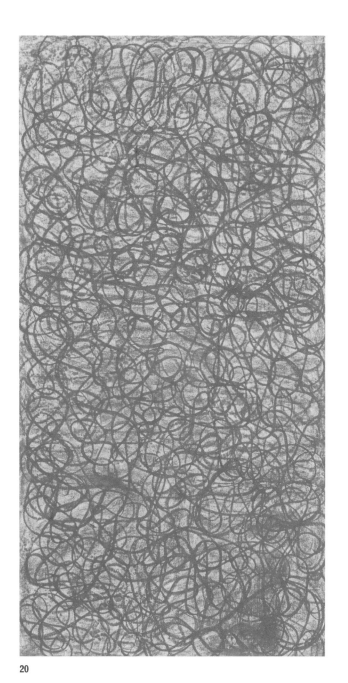

20

21

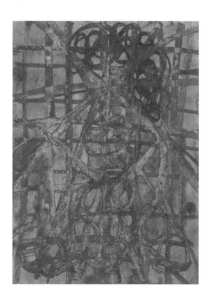

22

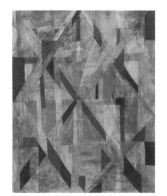

23

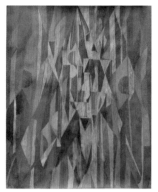

24

25

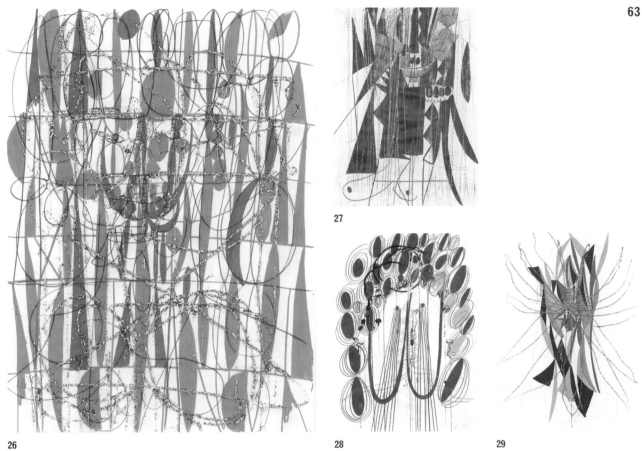

26

27

28

29

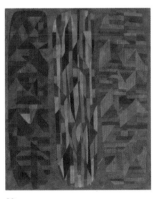

30

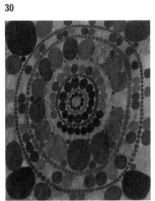

31

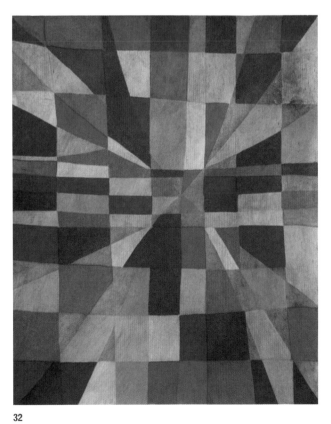

32

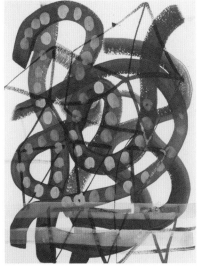

33

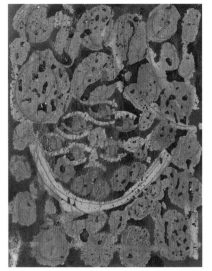

34

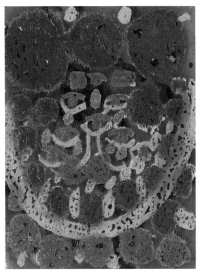

35

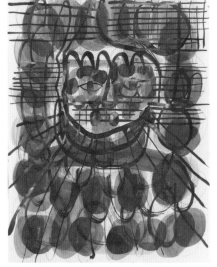

36

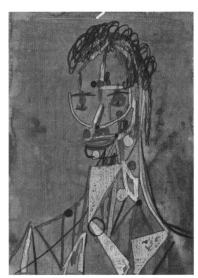

37

38

39

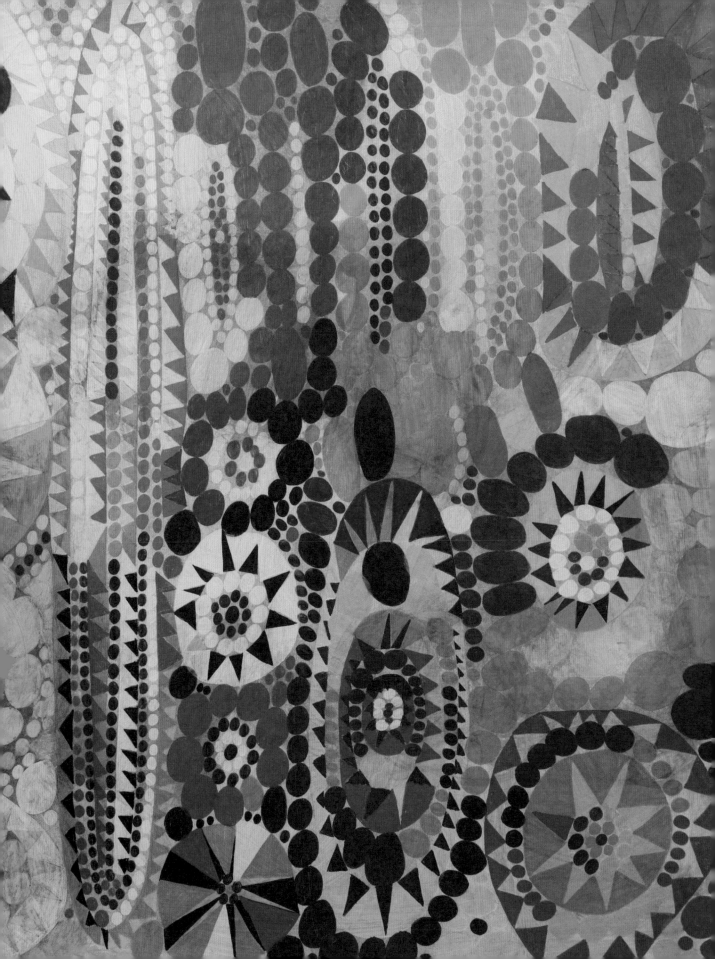

42

44

43

45

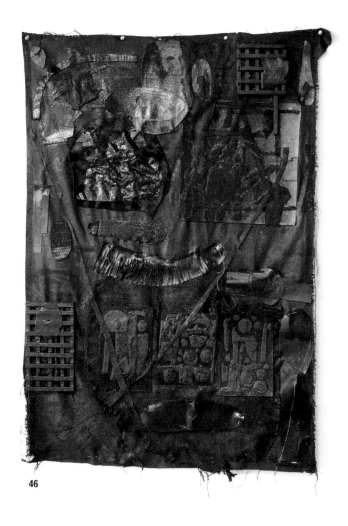

46

47

48

49

50

51

52

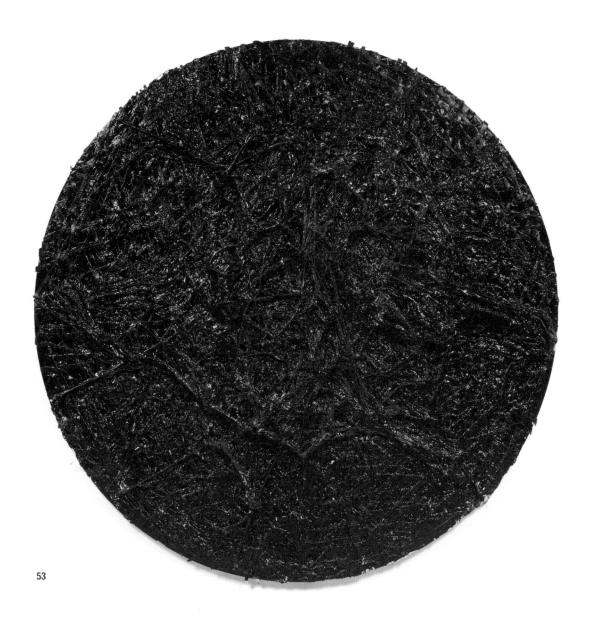

53

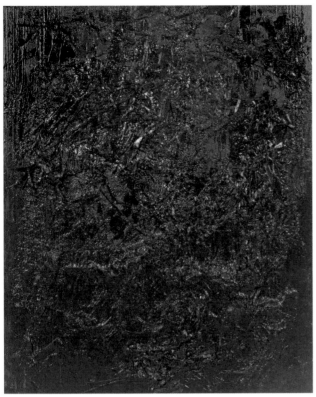

54

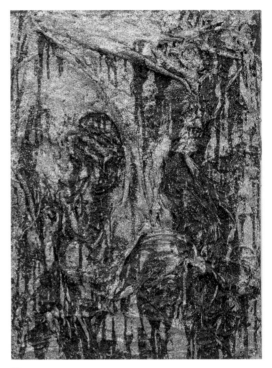

55

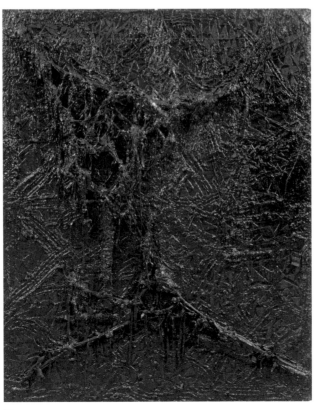

56

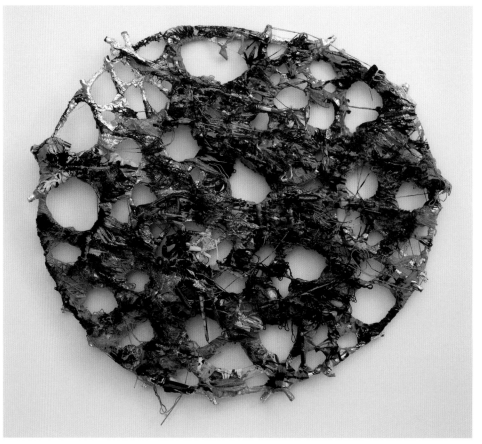

57

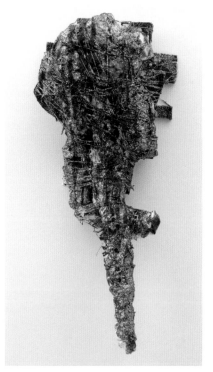

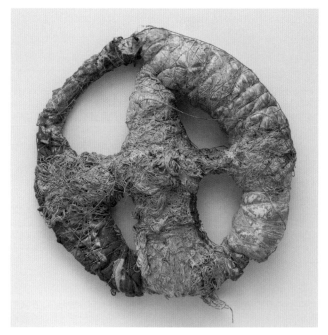

59

58

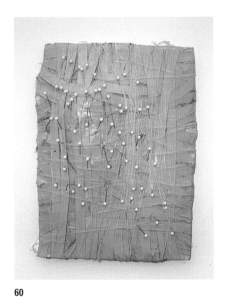

60

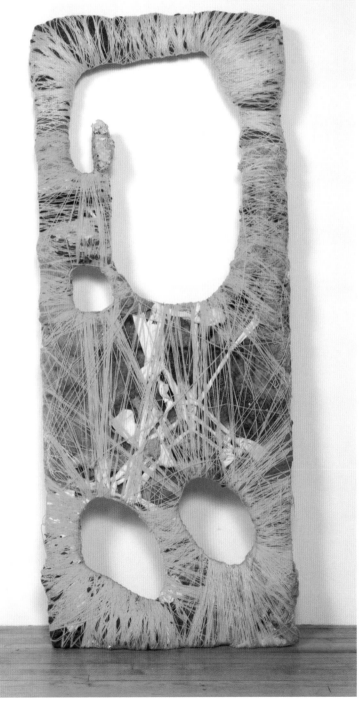

61

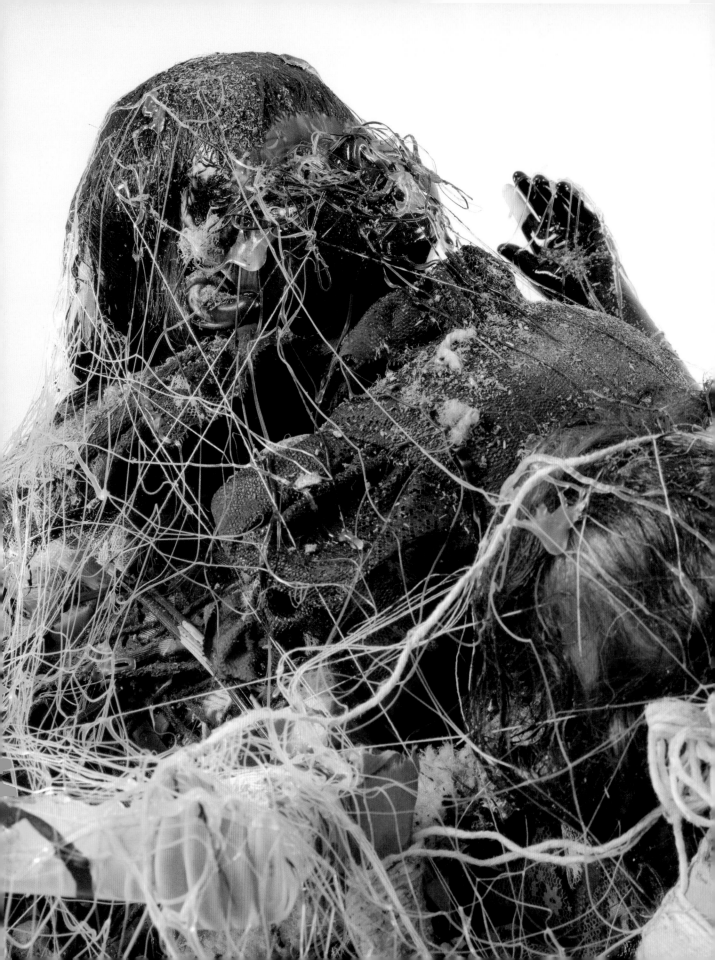

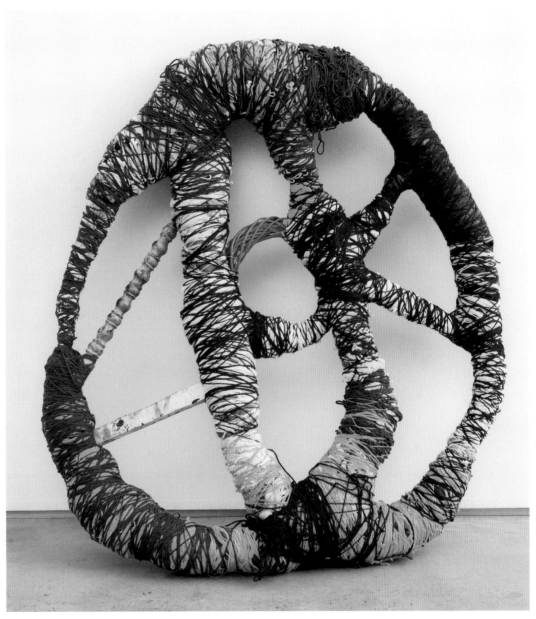

63

65

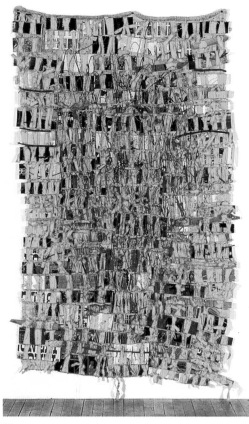

64

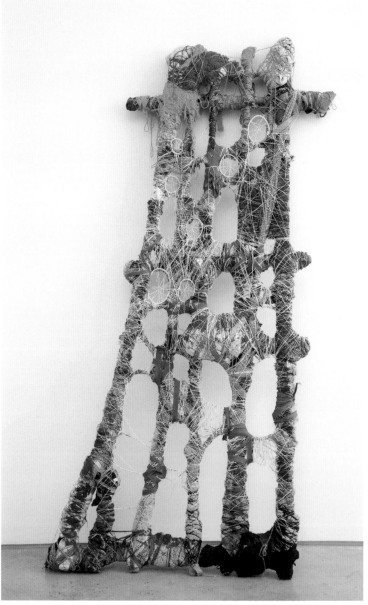

66

67

68

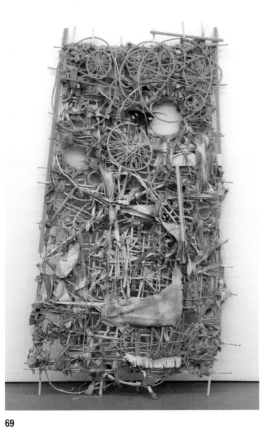

69

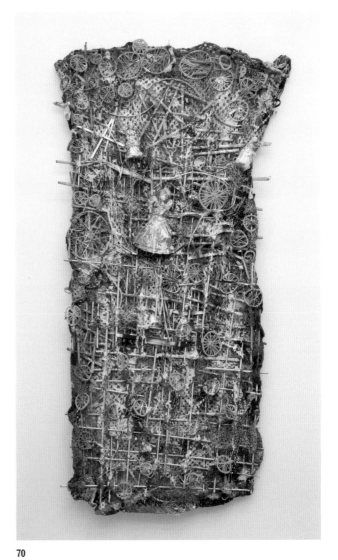

70

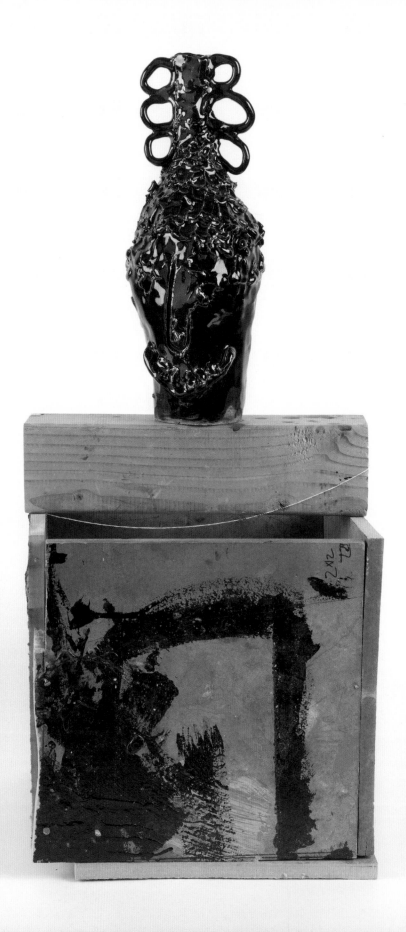

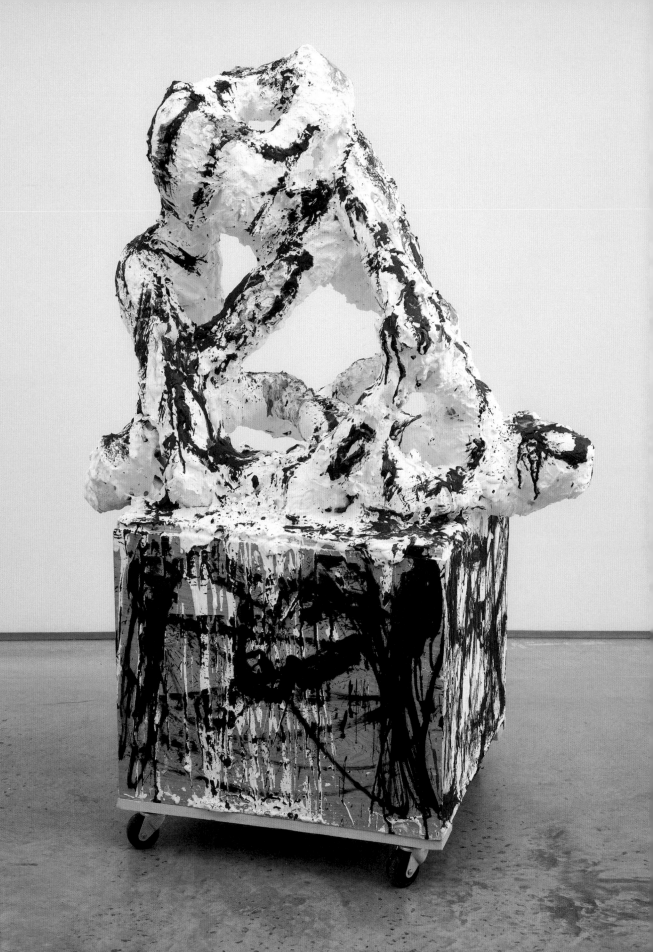

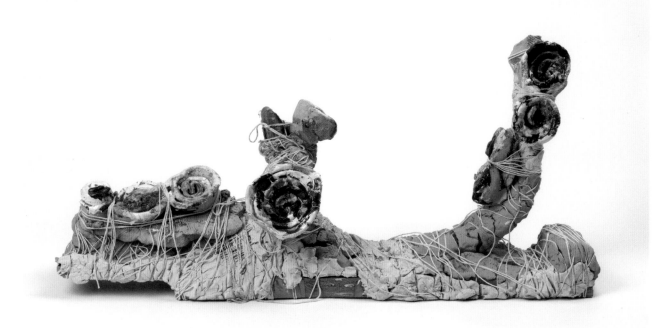

73

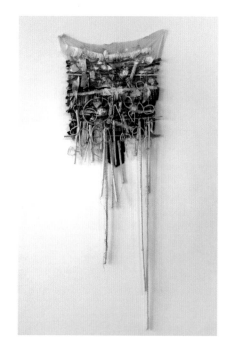

75

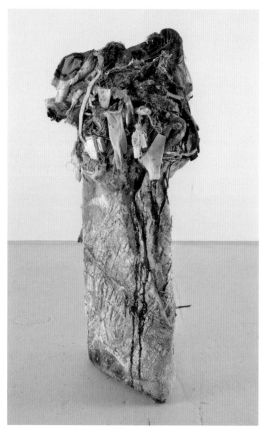

74

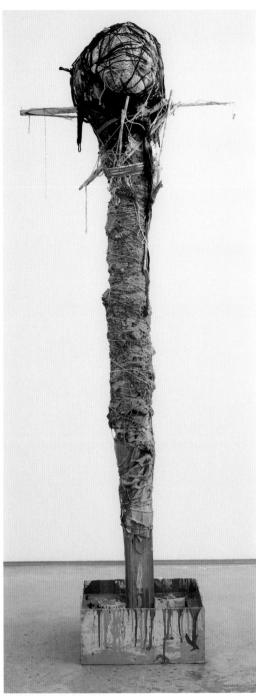

76

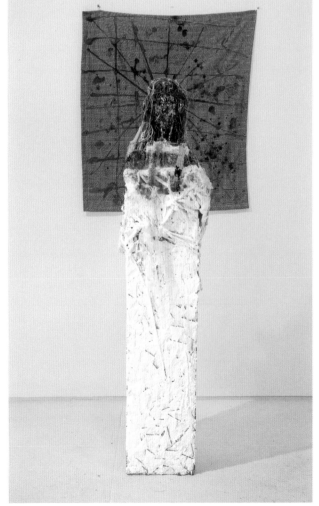

77

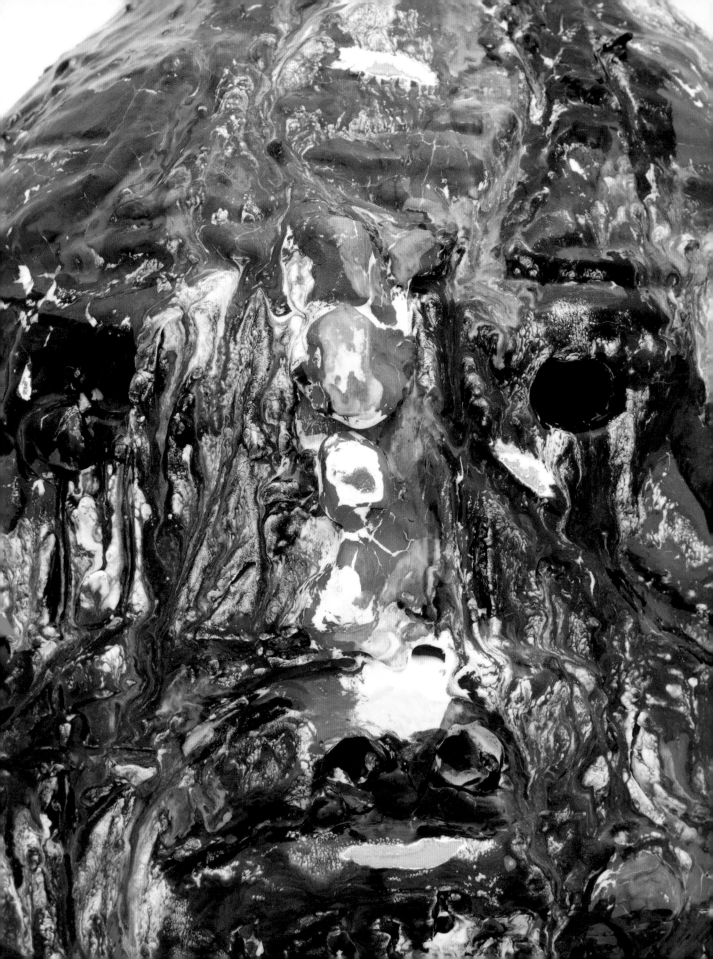

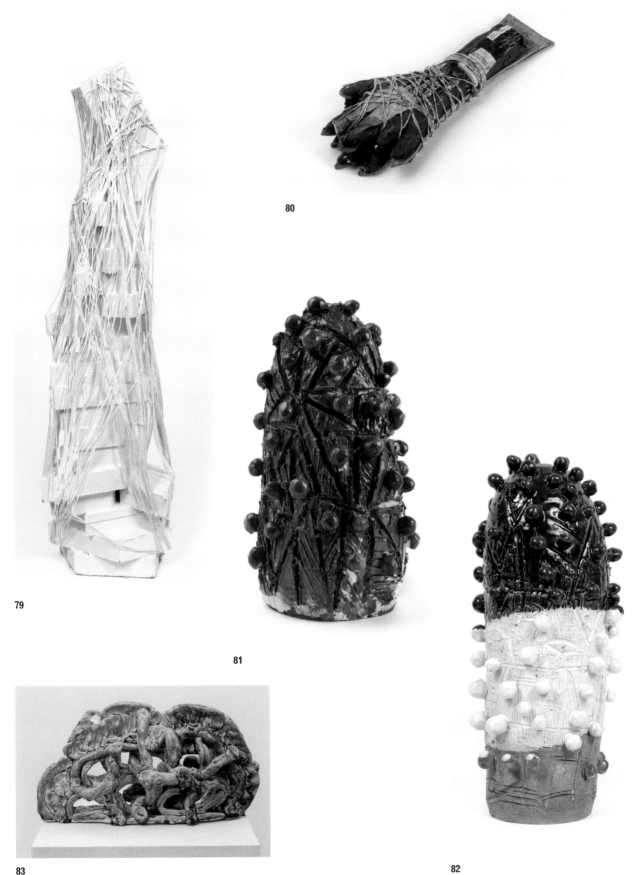

80

79

81

83

82

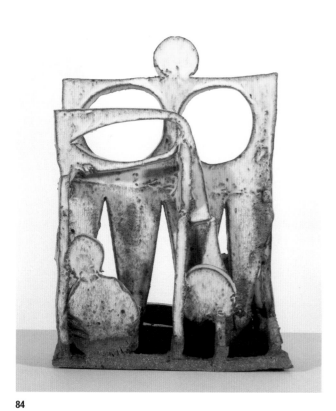

84

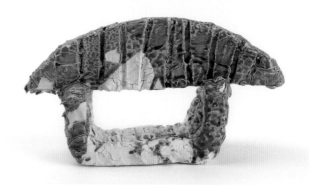

85

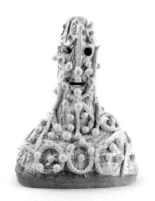

86

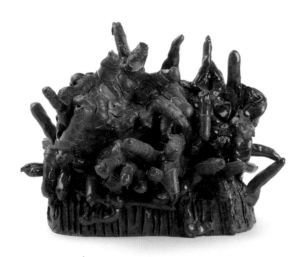

87

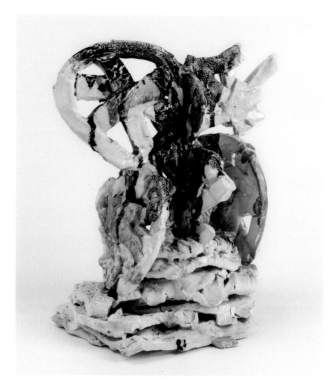

88

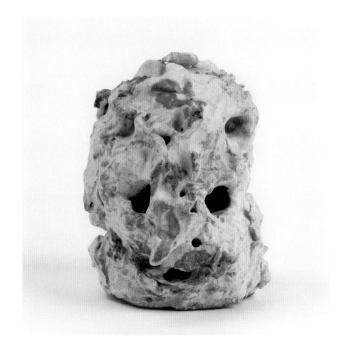

89

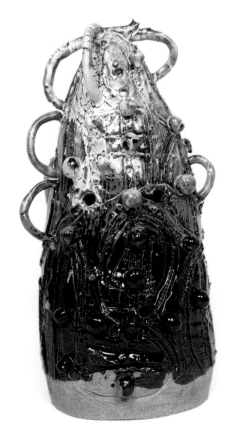

91

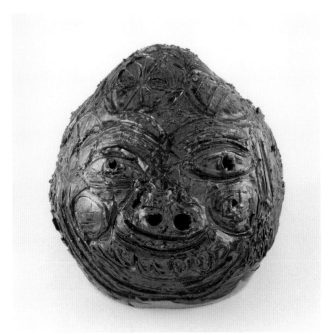

90

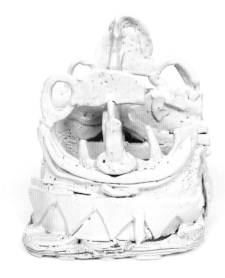

92

93

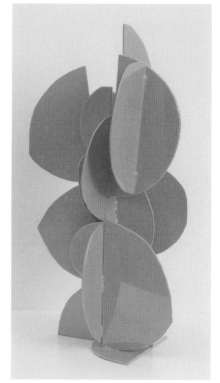

94

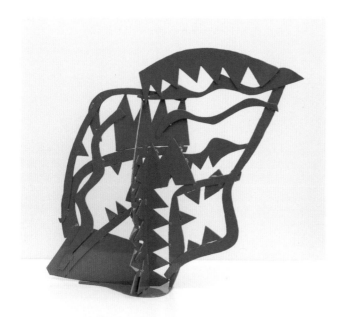

95

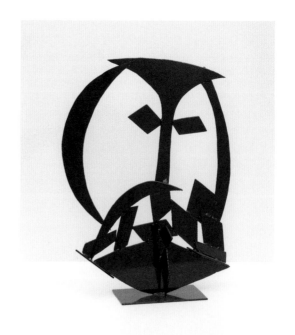

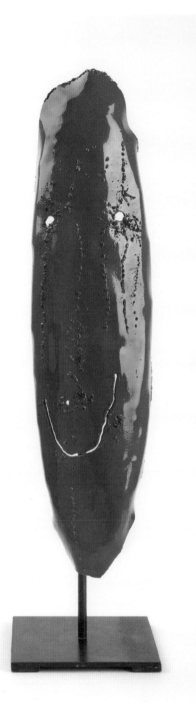

97

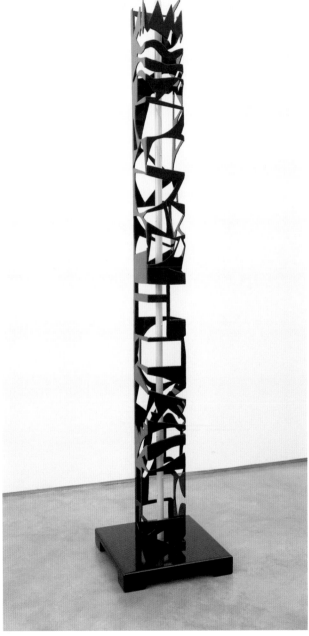

98

Biography and Selected Bibliography

William J. O'Brien
Born in Eastlake,
Ohio, 1975
Lives and works
in Chicago

Education

2005
MFA, Fiber and
Material Studies,
School of the Art
Institute of Chicago

1997
BA, Studio Art,
Loyola University
Chicago

Solo Exhibitions

2014
Almine Rech
Gallery, Paris

2013
Wet n' Wild,
Marianne Boesky
Gallery, New York

2012
SUM, Nerman
Museum of
Contemporary Art,
Overland Park,
Kansas

2011
William J. O'Brien,
Renaissance
Society at the
University of
Chicago

Works on Paper,
SHAHEEN Modern
and Contemporary
Art, Cleveland

2010
William J. O'Brien,
Shane Campbell
Gallery, Oak Park,
Illinois

2009
William J. O'Brien,
Marianne Boesky
Gallery, New York

William J. O'Brien,
Susanne Hilberry
Gallery, Detroit

2008
Death Rattle, World
Class Boxing,
Miami

2007
the axis mundi,
Shane Campbell
Gallery, Chicago

2006
*When Your Heart Is
on Fire, Smoke Gets
in Your Eyes,* Locust
Projects, Miami

2005
A Fairy Tale, Ingalls
and Associates,
Miami

*UBS 12 × 12: New
Artists/New Work:
William J. O'Brien,*
Museum of
Contemporary Art
Chicago

Selected Group Exhibitions

2013
Traces of Life,
Wentrup Gallery,
Berlin

2012
*All Good Things
Become Wild and
Free,* H. F. Johnson
Gallery of Art at
Carthage College,
Kenosha, Wisconsin
(exh. cat.)

The Magic Flute,
Golden Gallery,
New York

*Phantom Limb:
Approaches to
Painting Today,*
Museum of
Contemporary
Art Chicago

*Someone Puts a
Pineapple Together,*
Acme, Los Angeles

Surface in Volume,
Luce Gallery, Turin,
Italy

2011
*Josh Faught and
William J. O'Brien,*
Lisa Cooley,
New York

Making Is Thinking,
Witte de With,
Rotterdam,
The Netherlands
(exh. cat.)

Painted, Green
Gallery, Milwaukee

*Painting . . .
Expanded,* Espacio
1414, Santurce,
Puerto Rico

2010
*At Home/Not Home:
Works from the
Collection of Martin
and Rebecca
Eisenberg,* Hessel
Museum of Art,
Center for
Curatorial Studies,
Bard College,
Annandale-on-
Hudson, New York
(exh. cat.)

Drawing, Shane
Campbell Gallery,
Chicago

L'Aur'Amara,
Gallery MC,
New York; traveled
to the Générale
en Manufacture,
Paris; and
Centro Ricerche
Accademia di Brera
ex Chiesa di San
Carpoforo, Milan
(both 2011)

The Maginot Line,
David Castillo
Gallery, Miami

Mystic Visage,
World Class Boxing,
Miami

New Icon, Loyola
University Museum
of Art, Chicago

2009
*An Expanded Field
of Possibilities,*
Santa Barbara
Contemporary
Arts Forum, Santa
Barbara, California

In Stitches, Leila
Taghinia-Milani
Heller Gallery,
New York

Reskilling, Western
Front Exhibitions,
Vancouver, Canada

*Selected Works from
the MCA Collection,*
Museum of
Contemporary
Art Chicago

2008
*Andy Coolquitt,
Frank Haines,
William J. O'Brien*,
Krinzinger Projekte,
Galerie Krinzinger,
Vienna, Austria

Jesuvian Process,
Elizabeth Dee
Gallery, New York

Base: Object,
Andrea Rosen
Gallery, New York

Now You See It,
Aspen Art Museum,
Aspen, Colorado

2007
*Jesse Chapman,
Aliza Nisenbaum,
William J. O'Brien*,
Shane Campbell
Gallery, Chicago

*Makers and
Modelers: Works in
Ceramic*, Gladstone
Gallery, New York

*Sonotube® Forms:
Contemporary
Art and Transport*,
Santa Barbara
Contemporary
Arts Forum,
Santa Barbara,
California

So Wrong, I'm Right,
Blum and Poe,
Los Angeles

*Stuff: International
Contemporary Art
from the Collection
of Burt Aaron*,
Museum of
Contemporary Art
Detroit

*Project Space:
William J. O'Brien/
Anthony Pearson*,
Marianne Boesky
Gallery, New York

2006
Champagne, Nina
Menocal Projects,
Mexico City, Mexico

Cluster, Participant,
Inc., New York

*Josh Mannis,
Eric Lebofsky,
William J. O'Brien*,
Western Exhibitions,
Chicago

Modern Primitivism,
Shane Campbell
Gallery, Chicago

MIXART, James
Hotel, Chicago

Pathetisize,
Open End Gallery,
Chicago

2005
*Appropriating
Feminist Strategies*,
Gallery 1926,
Chicago

Bilingual, Ukranian
Institute of Modern
Art, Chicago

*Certain People I
Know*, Margaret
Thatcher Projects,
New York

CoDependent,
The Living Room for
Art Basel, Miami

Drawn Out,
Ukrainian Institute
of Modern Art,
Chicago

*Eagle Hand's
Moon and the
Orange Savior*,
Church of the
Friendly Ghost,
Austin, Texas

In Print2, Diamonds
on Archer, Chicago

Macerate, Around
the Coyote Gallery,
Chicago

*MFA Thesis
Exhibition*, Gallery 2,
School of the Art
Institute of Chicago

Stygine's Creek,
threewalls, Chicago,
video screening

*Summer Group
Show*, Contemporary
Art Workshop,
Chicago

Take My Hand,
threewalls, Chicago,
traveled to Nina
Menocal Gallery,
Mexico City

*We Created a
Monster*, Nina
Menocal Projects
for Art Basel, Miami

Winter Group Show,
Booster and Seven,
Chicago

2004
Abracadabra, Rocket
Projects, Miami

The Affair, Jupiter
Hotel, Fresh-Up
Club, Portland,
Oregon

Art Mule, The Stray
Show, Chicago

Art Poster Show,
Objex Artspace,
Miami

Click Formation,
Open End Gallery,
Chicago

*Eric Lebofsky, Josh
Mannis, William
O'Brien*, 1/Quarterly
Space, Chicago

G2 Group Show,
School of the Art
Institute of Chicago

Identity Crisis,
Marshall Arts
@ Delta Axis,
Memphis,
Tennessee

*Night of 1,000
Drawings*, Artist
Space, New York

*The Pilot
Conference*,
Symbology
Bathroom, Chicago

Small Victories,
Modest
Contemporary Art
Projects, Chicago

*3 on 3: 3 Straight
Artists Curate
3 Gay Artists*,
Higher Gallery,
Chicago

2003
La Superette,
Deitch Projects,
Participant, Inc.,
New York

100% Cotton,
Glasgow School
of Art, Glasgow,
Scotland

White Haute, Shaff
Gallery, Chicago

2001
*Annual Members
Show*, Greenwich
House Pottery,
New York

Out and About,
Benefit Invitation
Group Show,
SPACES Gallery,
Cleveland

1997
*Undergraduate
Thesis Show*,
Crown Center
Gallery, Loyola
University Chicago,
Chicago

Awards

Louis Comfort
Tiffany Foundation
Award, 2011

Artadia: The Fund
for Art and
Dialogue, 2007
Chicago Finalist,
Grant Recipient

Vermont Studio
Center, Full
Fellowship
Residency, 2005

Mellon Award,
Loyola University
Chicago, Chicago,
1997

Public Collections

Art Institute of
Chicago

Hara Museum of
Contemporary Art,
Tokyo

Perez Art Museum
of Miami (formerly
Miami Art Museum)

Selected Bibliography

2013
"Hit List." *Blouinartinfo.com/ Modern Painters* 25, no. 5 (May), 39.

2012
Orendorff, Danny. *All Good Things Become Wild and Free.* Kenosha, Wisconsin: H. F. Johnson Gallery of Art at Carthage College. Exh. cat.

2011
Bailey, Stephanie. "A Reaction to Globalized Production." *Aesthetica* 40 (April/May): 32–37.

Foumberg, Jason. "Review: William J. O'Brien/ Renaissance Society." *Newcity*, May 30, art.newcity. com/2011/05/30/ review-william-j- o'brienrenaissance- society/.

O'Toole, Sean. "Making Is Thinking." *frieze* 139 (May), 129.

Vogel, Sabine B. "William J. O'Brien." *Artforum* 49, no. 9 (May), 138.

2010
Grabner, Michelle. "New Icon." Artforum.com, July 21, artforum. com/archive/ id=26019.

Higgs, Matthew. *At Home/Not at Home: Works from the Collection of Martin and Rebecca Eisenberg.* Annandale-on- Hudson: Center for Curatorial Studies, Bard College, 2010. Exh. cat.

Rondeau, James. "Emerging Artists." *frieze* 128 (January/ February).

2009
Smith, Roberta. "Make Room for Video, Performance and Paint." *New York Times,* December 31.

Trelles, Emma. "New Acquisitions Add Vigorous Life to MAM Collection." *Palm Beach Arts Paper,* August 31.

2008
New York Art Beat Events, "'Base: Object' Exhibition." *NYArtBeat.com,* October 25. nyartbeat.com/ event/2008/2F2A.

Dault, Julia. "Akimblog: New York City." *Akimbo,* November 19, akimbo.ca/ akimblog/?id=242.

Grabner, Michelle. "Makers and Modelers: Works in Ceramic." *X-Tra* 10, no. 3: 54.

Oksenhorn, Stewart. "'Blindness Isn't an Option.'" *Aspen Times,* December 18, Entertainment section.

Reilly, Brittany. "Breakout Artists: Chicago's Next Generation of Image Makers." *Newcity,* April 24, Arts section.

Seckler, Judy. "Review: Makers and Modelers: Works in Ceramic." *Ceramics Monthly* (April): 24–26.

Sonnenborn, Katie. "Makers and Modellers." *frieze* 113 (March), 182.

Taft, Catherine. "'Base: Object,' Andrea Rosen Gallery." *Artforum. com,* November 20, artforum.com/ archive/id=21479.

Tranberg, Dan. "Review: 'Out of Sight' at Front Room Gallery, Cleveland." *Beautiful/Decay* (April 29).

Vogel, Sabine B. "Andy Coolquitt, Frank Haines, William J. O'Brien: Krinzinger Projekte." Artforum.com, May 5, artforum. com/archive/ id=20131.

Zuckerman Jacobson, Heidi. "Now You See It: Paintings That Demand a Second Look." *Aspen Magazine* (Holiday 2008–09): 66.

Zuckerman Jacobson, Heidi, Peter Eleey, Jeremy Sigler, George Stranahan, and Paul Valery. *Now You See It.* Aspen: Aspen Art Press.

2007
Darwent, Charles. "Reviews: Makers and Modelers: Works in Ceramic." *Crafts Magazine for Contemporary Art* (November/ December): 68.

Fry, Naomi. "Makers and Modelers, Gladstone Gallery." *Artforum.com,* October 2, artforum.com/ archive/id=17964

Smith, Roberta. "It's Just Clay, but How About a Little Respect?" *New York Times,* September 7, Weekend Arts, Fine Arts/ Leisure section.

Smith, Roberta. "Museum and Gallery Listings: 'Makers and Modelers: Works in Ceramic'." *New York Times,* September 28, Art and Design section.

Yood, James. "William J. O'Brien: Shane Campbell Gallery." *Artforum* 46, no. 4 (December), 360.

2006
Moreno, Gean. "William J. O'Brien." *Art Papers* 30, no. 2 (March/April): 60.

2005
Hawkins, Margaret. "Take My Hand." *Chicago Sun-Times,* February 4, Weekend section.

Heidemann, Jason A. "Out on the Town . . . Taking in Queer Culture." *Time Out Chicago* (October 20–27): 98.

Nusser, Madeline. "Macerate." *Time Out Chicago* (June 16–23).

Tyson, Josh. "Group Show: Booster and Seven." *Time Out Chicago* (December 15–29).

Weinberg, Lauren. "Lebofsky, Mannis and O'Brien." timeoutchicago. com, March 11, timeoutchicago. com/arts-culture/ art-design/42926/ lebofsky-man- nis-and-obrien.

Checklist

All boldface numbers before titles refer to plate numbers.

Wearing Scarf like a Veil #1, 2005
Collage
27 × 19 in.
(68.6 × 48.3 cm)
Collection of
Heiji Choy Black
and Brian Black

Untitled, 2006
Colored pencil and
ink on paper
13 ⅞ × 16 ⅞ in.
(35.2 × 42.9 cm)
Collection of
Scott J. Hunter

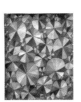

Untitled, 2007
Ink and colored
pencil on paper
16 ⅞ × 13 ⅞ in.
(42.9 × 35.2 cm)
Collection of
Bradford L.
Ballast and David
Hallett Hill

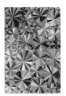

4. *Untitled*, 2007
Colored pencil and
ink on paper
62 × 42 in.
(157.5 × 106.7 cm)
Collection of Dana
Westreich Hirt

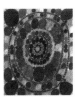

31. *Untitled*, 2007
Ink and colored
pencil on paper
16 ⅞ × 13 ⅞ in.
(42.9 × 35.2 cm)
Collection of James
and Cheryll Raff

*Eulogy to the Self
Transparent*, 2005
Felt and pins
72 × 72 in.
(182.9 × 182.9 cm)
Collection of
Aviva Samet and
James Matanky

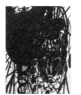

Untitled, 2007
Ink and acrylic
on paper
25 ½ × 19 ¾ in.
Collection of
Laura De
Ferrari and
Marshall Front

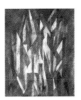

Untitled, 2007
Colored pencil
and ink on paper
16 ⅞ × 13 ⅞ in.
(42.9 × 32.2 cm)
Collection of
Heiji Choy Black
and Brian Black

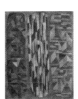

30. *Untitled*, 2007
Colored pencil
and ink on paper
16 ⅞ × 13 ⅞ in.
(42.9 × 35.2 cm)
Collection of
Aviva Samet and
James Matanky

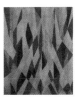

Untitled, 2007
Ink and colored
pencil on paper
16 ⅞ × 13 ⅞ in.
(42.9 × 35.2 cm)
Collection of
James and
Cheryll Raff

Untitled, 2006
Ink on paper
19 ⅝ × 25 ½ in.
(49.8 × 64.8 cm)
Private collection

25. *Untitled*, 2007
Colored pencil and
ink on paper
16 ⅞ × 13 ⅞ in.
(42.9 × 35.2 cm)
Collection of
Lorin Adolph

Untitled, 2007
Colored pencil and
ink on paper
25 ⅛ × 19 ⅝ in.
(64.8 × 48.8 cm)
Collection of
Laura De Ferrari
and Marshall Front

24. *Untitled*, 2007
Ink and colored
pencil on paper
16 ⅞ × 13 ⅞ in.
(42.9 × 35.2 cm)
Collection of
Nancy and
Robert Mollers

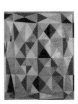

3. *Untitled*, 2007
Ink and colored
pencil on paper
16 ⅞ × 13 ⅞ in.
(42.9 × 35.2 cm)
Collection of James
and Cheryll Raff

60. *Untitled*, 2007
Mixed media
17 ½ × 7 ¼ × 2 ½ in.
(44.4 × 18.4 × 6.35 cm)
Collection of
Dirk Denison and
David Salkin

70. *Death of Mother*,
2007
Mixed media
on fabric
86 × 50 × 4 in.
(218.4 × 127 × 10.2 cm)
Courtesy of the artist
and Shane Campbell
Gallery, Chicago

46. *Night Sounds*, 2007
Mixed media on fabric
44 × 32 in.
(111.8 × 81.3 cm)
Collection of
Dr. David Walega and
Mr. Christopher
Ambroso

71. *Master and
Servant*, 2007
Glazed ceramic, yarn,
paint, and wood
30 ¼ × 13 ½ × 13 ½ in.
(76.2 × 34.3 × 34.3 cm)
Collection of
Will Megson

Untitled, 2007
Glazed ceramic
8 ¼ × 10 × 2 ½ in.
(30 × 25.4 × 6.3 cm)
Private collection

Untitled, 2008
Ink on paper
Diptych, each:
71 ½ × 42 in. (181.6 ×
106.7cm) Framed,
each: 76 × 45 × 2 in.
Courtesy of the
artist and Marianne
Boesky Gallery,
New York

Untitled, 2007
Mixed media
14 ½ × 14 ½ × 16 in.
(36.8 × 36.8 × 40.6 cm)
Courtesy of the artist
and Shane Campbell
Gallery, Chicago

64. *Core Values*, 2007
Mixed media on fabric
78 × 48 in.
(198.1 × 121.9 cm)
Collection of
Maura Ann and
Deirdre McBreen

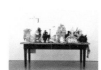

18. *Cinaedus Table,
MDCCLXXV*, 2007
Ceramic, mixed
media, and found
objects
65 × 84 × 30 in.
(165.1 × 213.4 × 76.2 cm)
Collection of
Martin and Rebecca
Eisenberg

Untitled, 2007
Glazed ceramic
9 ¾ × 7 × 5 in.
(24.8 × 17.8 × 12.7 cm)
Collection of
Nancy and David
Frej, Chicago

6. *Untitled*, 2007
Glazed ceramic
15 ¾ × 8 × 6 in.
(40 × 20.3 × 15.2 cm)
Collection of Dr.
David Walega and
Mr. Christopher
Ambroso

Untitled, 2008
Ink on paper
10 ⅞ × 6 ⅛ in.
(27.6 × 17.5 cm)
Courtesy of the
artist and Marianne
Boesky Gallery,
New York

67. *Dishonesty
(CHANGE)*, 2007
Mixed media
on fabric
62 × 25 in.
(157.5 × 63.5 cm)
Collection of
Theodore J. Argiris Jr.

75. *Sticky Fingers*, 2007
Mixed media
on fabric
72 × 27 ½ in.
(182.9 × 69.9 cm)
Collection of
Nancy and David
Frej, Chicago

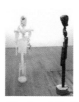

*King Lear & the Bandit
Queen*, 2007
Mixed media
Two parts, each:
56 × 8 × 24 in.
(142.2 × 20.3 × 61 cm)
Collection of
Theodore J. Argiris Jr.

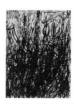

19. *Untitled*, 2007
Glazed ceramic
10 × 7 × 7 in.
(25.4 × 17.8 ×
17.8 cm)
Collection of
Scott J. Hunter

47. *Untitled*, 2008
Ink on paper
25 ½ × 19 ½ in.
(64.8 × 49.5 cm)
Courtesy of the
artist and Marianne
Boesky Gallery,
New York

Untitled, 2008
Ink on paper
11 × 8 ¼ in.
(27.9 × 21 cm)
Courtesy of the
artist and Marianne
Boesky Gallery,
New York

Untitled, 2008
Photocopy and
ink on paper
8 ½ × 11 in.
(21.6 × 27.9 cm)
Courtesy of the
artist and Marianne
Boesky Gallery,
New York

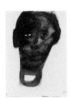

5. *Untitled*, 2008
Ink on paper
12 ¾ × 8 ⅞ in.
(32.4 × 22.5 cm)
Courtesy of the
artist and Marianne
Boesky Gallery,
New York

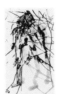

Untitled, 2008
Ink on paper
10 × 8 in.
(25.4 × 20.3 cm)
Courtesy of the
artist and Marianne
Boesky Gallery,
New York

52. *Untitled*, 2008
Ink on paper
72 × 42 in.
(182.9 × 106.7 cm)
Marilyn and Larry
Fields Collection

Untitled, 2008
Mixed media
on paper
11 ⅞ × 8 ⅞ in.
(30.2 × 22.5 cm)
Courtesy of
the artist and
Marianne Boesky
Gallery, New York

Untitled, 2008
Mixed media
on paper
12 × 9 in.
(30.5 × 22.9 cm)
Courtesy of
the artist and
Marianne Boesky
Gallery, New York

Untitled, 2008
Ink on paper
10 × 8 in.
(25.4 × 20.3 cm)
Courtesy of the
artist and Marianne
Boesky Gallery,
New York

Untitled, 2008
Ink on paper
11 × 8 ½ in.
(27.9 × 21.6 cm)
Courtesy of the
artist and Marianne
Boesky Gallery,
New York

Untitled, 2008
Ink on paper
8 ½ × 5 ⅜ in.
(21.6 × 13.7 cm)
Courtesy of the
artist and Marianne
Boesky Gallery,
New York

Untitled, 2008
Ink on paper
15 × 10 in.
(38.1 × 25.4 cm)
Courtesy of the
artist and Marianne
Boesky Gallery,
New York

Untitled, 2008
Mixed media
on paper
11 ⅞ × 8 ⅞ in.
(30.2 × 22.5 cm)
Courtesy of
the artist and
Marianne Boesky
Gallery, New York

Untitled, 2008
Mixed media on
paper
12 × 8 ⅞ in.
(30.5 × 22.5 cm)
Courtesy of the
artist and Marianne
Boesky Gallery,
New York

Untitled, 2008
Ink on paper
11 ⅞ × 8 ⅞ in.
(30.2 × 22.5 cm)
Courtesy of the
artist and Marianne
Boesky Gallery,
New York

Untitled, 2008
Gouache on paper
11 ⅞ × 8 ⅞ in.
(30.2 × 22.5 cm)
Courtesy of the
artist and Marianne
Boesky Gallery,
New York

Untitled, 2008
Ink on paper
72 × 42 in.
(182.9 × 106.7 cm)
Collection of
Susan and
Steve Felker

Untitled, 2008
Ink on paper
12 × 9 in.
(30.5 × 22.9 cm)
Courtesy of
the artist and
Marianne Boesky
Gallery, New York

Untitled, 2008
Mixed media
on paper
12 × 9 in.
(30.5 × 22.9 cm)
Courtesy of the
artist and Marianne
Boesky Gallery,
New York

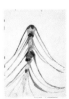

Untitled, 2008
Color pencil and
graphite on paper
12 ¾ × 9 in.
(32.4 × 22.9 cm)
Courtesy of the
artist and Marianne
Boesky Gallery,
New York

96

23. *Untitled*, 2008
Ink and colored
pencil on paper
16 ⅞ × 13 ⅞ in.
(42.9 × 35.2 cm)
Private collection

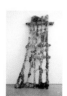

66. *Untitled*, 2008
Mixed media
99 × 37 × 6 in.
(251.5 × 94 × 15.2 cm)
Courtesy of the
artist and Marianne
Boesky Gallery,
New York

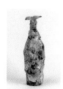

Untitled, 2008
Glazed ceramic
15 × 6 × 5 in.
(38.1 × 15.2 × 12.7 cm)
Collection of Howard
and Donna Stone

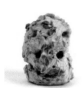

Untitled, 2009
Glazed ceramic
7 ¾ × 7 ¾ × 6 in.
(19.7 × 19.7 × 15.2 cm)
Collection of Dana
Westreich Hirt

Untitled, 2009
Glazed ceramic
8 ¼ × 8 ¼ × 5 ¼ in.
(21 × 21 × 13.3 cm)
Collection of
David Egeland and
Andy Friedman

Untitled, 2010
Colored pencil
on paper
24 × 18 in.
(61 × 45.7 cm)
Courtesy of the
artist and Marianne
Boesky Gallery,
New York

54. *Untitled*, 2008
Enamel, fabric,
cardboard, and
plaster on canvas
82 × 66 in.
(208.3 × 167.6 cm)
Marilyn and Larry
Fields Collection

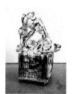

72. *Untitled*, 2008
Mixed media
39 × 28 × 54 in.
(99.1 × 71.1 × 137.2 cm)
Courtesy of the
artist

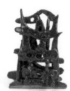

Untitled, 2008
Glazed ceramic
12 × 9 × 6 ½ in.
(30.5 × 22.9 ×
16.5 cm)
Collection of Howard
and Donna Stone

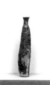

Untitled, 2009
Glazed ceramic
23 × 5 × 5 in.
(58.4 × 12.7 × 12.7 cm)
Collection of Nancy
and Robert Mollers

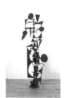

9. *Untitled*, 2009
Powder-coated steel
68 ½ × 20 ½ × 9 in.
(174 × 52.1 × 22.9 cm)
Collection of Jason
Pickleman and
Leslie Bodenstein

Untitled, 2010
Oil pastel, pencil,
and ink wash
16 ⅛ × 11 ⅝ in.
(41 × 29.5 cm)
Courtesy of the
artist and Marianne
Boesky Gallery,
New York

56. *Untitled*, 2008
Mixed media
on canvas
80 × 66 ½ in.
(203.2 × 168.9 cm)
Collection of
Nancy and David
Frej, Chicago

12. *Untitled*, 2008
Mixed media
37 × 29 × 50 in.
(94 × 73.7 × 127 cm)
Courtesy of
the artist

20. *Untitled*, 2009
Oil pastel on paper
62 × 37 in.
(157.5 × 94 cm)
Courtesy of the
artist and Marianne
Boesky Gallery,
New York

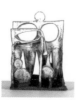

84. *Untitled*, 2009
Glazed ceramic
11 ½ × 8 ½ × 6 in.
(29.2 × 21.6 × 15.2 cm)
Collection of
David Egeland and
Andy Friedman

Untitled, 2010
Ink on paper
9.5 × 8 in.
(24.1 × 20.3 cm)
Courtesy of the
artist and Shane
Campbell Gallery,
Chicago

Untitled, 2010
Oil pastel, pencil,
and ink wash
16 ⅛ × 11 ⅝ in.
(41 × 29.5 cm)
Hort Family
Collection

Untitled, 2010
Oil pastel, pencil,
and ink wash
15 ¾ × 11 ⅝ in.
(40 × 29.5 cm)
Hort Family
Collection

16. *Untitled*, 2010
Mixed media
22 × 15 × 7 ½ in.
(55.9 × 38.1 × 19.1 cm)
Collection of
Paul and Linda
Gotskind

90. *Untitled*, 2010
Glazed ceramic
12 × 13 × 13 in.
(30.5 × 33 × 33 cm)
Marilyn and
Larry Fields
Collection

28. *Untitled*, 2011
Colored pencil and
glitter paint on
paper
24 × 17 in.
(61 × 43.2 cm)
Private collection,
Chicago

29. *Untitled*, 2011
Colored pencil,
graphite, and glitter
on paper
24 × 18 in.
(61 × 45.7 cm)
Hort Family
Collection

88. *Untitled*, 2011
Glazed ceramic
13 × 11 × 7 in.
(33 × 27.9 × 17.8 cm)
Collection of
Jim Dempsey
and Patricia
Pac-Dempsey

Untitled, 2010
Mixed media
on canvas
41 × 31 × 3 in.
(104.1 × 78.7 × 7.6 cm)
Dirk Denison and
David Salkin

Untitled, 2010
Mixed media
35 × 14 ½ × 7 ½ in.
(88.9 × 36.8 × 19.1 cm)
Courtesy of the
artist

Untitled, 2010
Glazed ceramic
19 × 10 × 9 in.
(46.4 × 23.5 × 25.4 cm)
Collection of Dr.
David Walega and
Mr. Christopher
Ambroso

Untitled, 2011
Colored pencil and
glitter paint on
paper
24 × 17 in.
(61 × 43.2 cm)
Private collection,
Chicago

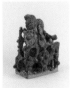

Untitled, 2011
Glazed ceramic
14 ½ × 12 × 7 in.
(36.8 × 30.5 × 17.8 cm)
Collection of
John Corbett and
Terri Kapsalis

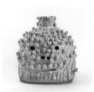

Untitled, 2011
Glazed ceramic
15 × 14 × 11 in.
(38.1 × 35.6 × 27.9 cm)
Collection of
Dirk Denison and
David Salkin

14. *Untitled*, 2010
Mixed media
24 × 18 × 6 in.
(61 × 45.7 × 15.2 cm)
Collection of Kim
and Joseph Mimran

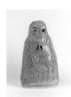

Untitled, 2010
Glazed ceramic
18 × 10 ½ × 7 in.
(45.7 × 26.7 × 17.8 cm)
Marilyn and
Larry Fields
Collection

26. *Untitled*, 2011
Colored pencil,
graphite, and glitter
on paper
24 × 18 in.
(61 × 45.7cm)
Courtesy of the artist
and Marianne Boesky
Gallery, New York

27. *Untitled*, 2011
Colored pencil and
glitter paint on
paper
24 × 17 in.
(61 × 43.2 cm)
Collection of
Scott J. Hunter

Untitled, 2011
Glazed ceramic
17 ½ × 15 × 10 in.
(44.5 × 38.1 × 25.4 cm)
Collection of
the artist and
Shane Campbell
Gallery, Chicago

7. *Untitled*, 2011
Glazed ceramic
14 ½ × 10 × 9 in.
(36.8 × 25.4 × 22.9 cm)
Collection of
Howard and Donna
Stone

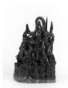

Untitled, 2011
Glazed ceramic
17 × 11 ½ × 9 ½ in.
(43.2 × 29.2 × 24.1 cm)
Collection of
Howard and Donna
Stone

Untitled, 2011
Glazed ceramic
8 × 8 × 1 in.
(20.3 × 20.3 × 2.5 cm)
Courtesy of the
artist and Marianne
Boesky Gallery,
New York

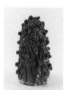

81. *Untitled*, 2011
Glazed ceramic
17 ½ × 10 × 10 in.
(44.5 × 25.4 × 25.4 cm)
Courtesy of the
artist and Shane
Campbell Gallery,
Chicago

Untitled, 2011
Glazed ceramic
5 ¼ × 8 ¼ × 6 ¾ in.
(13.3 × 21 × 17.1 cm)
Courtesy of
the artist

85. *Untitled*, 2011
Glazed ceramic
8 × 14 ½ × 1 in.
(20.3 × 36.8 × 2.5 cm)
Courtesy of
the artist

Untitled, 2012
Colored pencil, ink,
and glitter on paper
67 ½ × 36 in.
(171.5 × 91.4 cm)
Courtesy of the
artist and Marianne
Boesky Gallery,
New York

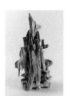

13. *Untitled*, 2011
Glazed ceramic
21 × 9 × 11 in.
(53.3 × 22.9 × 27.9 cm)
Collection of
Howard and Donna
Stone

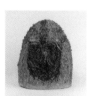

8. *Untitled*, 2011
Glazed ceramic
18 ½ × 15 ½ × 11 in.
(47 × 39.4 × 27.9 cm)
Courtesy of the
artist and Shane
Campbell Gallery,
Chicago

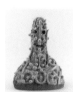

86. *Untitled*, 2011
Glazed ceramic
18 × 9 × 14 in.
(45.7 × 22.9 × 35.6 cm)
Courtesy of the
artist and Shane
Campbell Gallery,
Chicago

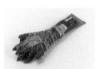

80. *Untitled*, 2011
Ceramic
2 ¼ × 7 × 17 ½ in.
(5.7 × 17.8 × 44.5 cm)
Courtesy of the
artist

97. *Untitled (I)*, 2011
Powder coated steel
and stand
25 ½ × 6 × 2 ½ in.
(64.8 × 15.2 × 6.3 cm)
Collection of
Howard and Donna
Stone

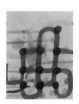

Untitled, 2012
Colored pencil, ink,
and glitter on paper
68 × 42 in.
(172.7 × 106.7 cm)
Anne Booth Dayton,
New York

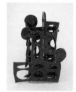

Untitled, 2011
Glazed ceramic
17 ½ × 13 × 11 in.
(44.5 × 33 × 27.9 cm)
Collection of
Howard and Donna
Stone

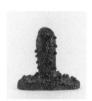

Untitled, 2011
Glazed ceramic
18 ½ × 20 ½ × 8 in.
(47 × 52.1 × 20.3 cm)
Courtesy of the
artist and Shane
Campbell Gallery,
Chicago

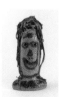

Untitled, 2011
Glazed ceramic
17 ½ × 9 × 5 in.
(44.5 × 22.9 × 12.7 cm)
Courtesy of the
artist and Shane
Campbell Gallery,
Chicago

59. *Untitled*, 2011
String, fabric, wood,
paint, and mixed media
32 × 35 × 8 in.
(81.3 × 88.9 × 20.3 cm)
Courtesy of the
artist and Shane
Campbell Gallery,
Chicago

Untitled, 2012
Colored pencil, ink,
glitter, and felt
on paper
68 × 36 in.
(172.7 × 91.4 cm)
Private collection,
New York

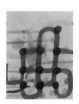

39. *Untitled*, 2012
Gouache, pencil
and ink on paper
14 × 11 in.
(35.6 × 27.9 cm)
Courtesy of the
artist

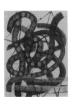

33. *Untitled*, 2012
Acrylic on paper
14.5 × 11 in.
(36.8 × 27.9 cm)
Courtesy of the
artist

38. *Untitled*, 2012
Oil pastel, ink, and
pencil on paper
12 × 9 in.
(30.5 × 22.9 cm)
Courtesy of the
artist

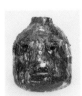

78. *Blood Face*, 2012
Glazed ceramic
15.5 × 14 × 14 in.
(39.8 × 35.6 ×
35.6 cm)
Collection of Dana
Westreich Hirt

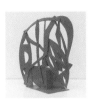

17. *Windsor*, 2012
Powder-coated steel
23 × 19 × 15 in.
(58.4 × 48.3 × 38.1 cm)
Courtesy of
the artist

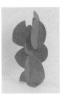

94. *Untitled*, 2012
Powder-coated
steel
29 ½ × 13 × 16 in.
(75 × 33 × 40.5 cm)
Courtesy of the
artist and Marianne
Boesky Gallery,
New York

Untitled, 2013
Mixed media on
wood
40 ½ × 67 ½ in.
(102.9 × 171.4 cm)
Courtesy of
the artist

40. *Untitled*, 2012
Gouache, pencil
and ink on paper
14 × 11 in.
(35.6 × 27.9 cm)
Courtesy of the
artist

34. *Untitled*, 2012
Oil pastel, ink, and
pencil on paper
12 × 9 in.
(30.5 × 22.9 cm)
Courtesy of the
artist

Untitled, 2012
Glazed ceramic
15 × 7 × 13 in.
(38.1 × 17.8 × 33cm)
Marilyn and Larry
Fields Collection

Walls and Doors,
2012
Powder-coated steel
16 × 27 ½ × 28 in.
(40.6 × 69.9 × 71.1 cm)
Courtesy of the
artist and Marianne
Boesky Gallery,
New York

93. 12 unique works,
each: *Untitled*, 2013
Felt on felt
24 × 20 in.
(61 × 50.8 cm)
Courtesy of the
artist

Untitled, 2013
Mixed media on
wood
44 × 81 in.
(111.8 × 205.7 cm)
Courtesy of
the artist

36. *Untitled*, 2012
Gouache, pencil and
ink on paper
14 × 11 in.
(35.6 × 27.9 cm)
Courtesy of the
artist

35. *Untitled*, 2012
Oil pastel, ink, and
pencil on paper
12 × 9 in.
(30.5 × 22.9 cm)
Courtesy of the
artist

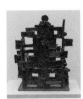

Untitled, 2012
Glazed ceramics
18 × 13 × 15 in.
(45.7 × 33 × 38.1 cm)
Collection of Curt
and Jennifer
Conklin

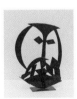

Kenilworth, 2012
Powder-coated steel
27 × 20 ½ × 8 ½ in.
(68.6 × 52.1 × 21.6 cm)
Courtesy of the
artist and Marianne
Boesky Gallery,
New York

Untitled, 2013
Colored pencil and
ink on paper
72 × 60 in.
(182.9 × 152.4 cm)
Courtesy of the
artist

Untitled, 2013
Glazed ceramic
52 × 21 × 21 in.
(132.1 × 53.3 × 53.3 cm)
Collection of
David Egeland and
Andy Friedman

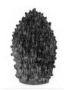

Untitled, 2013
Glazed ceramic
44 × 25 × 28 in.
(111.8 × 63.5 × 71.1 cm)
Collection of
Rodney D. Lubeznik

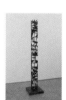

98. *Untitled*, 2013
Powder-coated steel
103 × 21 × 21 in.
(261.6 × 53.3 × 53.3 cm)
Courtesy of the
artist and Marianne
Boesky Gallery,
New York

Image not
available at
time of print

Untitled, 2014
Wood and ceramic
construction to be
completed on site
Dimensions variable
Courtesy of the artist

**Works illustrated
but not included in
the exhibition**

1. *Untitled*, 2010
Colored pencil,
graphite, and glitter
on paper
24 × 18 in.
(61 × 45.7 cm)

2. *Untitled*, 2012
Colored pencil on
paper
67 ½ × 36 in.
(171.5 × 91.4 cm)

10. *Evening Star*,
2009
Powder coated steel
31 × 17 × 23 in.
(78.7 × 43.2 ×
58.4 cm)

11. *Untitled*, 2008
Mixed media
81 × 40 × 8 in.
(205.7 × 101.6 ×
20.3 cm)

15. *Untitled* (detail),
2008
Glazed ceramic,
enamel, plaster, ta-
ble, and ink on paper
88 ½ × 72 ½ × 55 in.
(224.8 × 184.1 ×
139.7 cm)

32. *Untitled*, 2007
Colored pencil and
ink on paper
16 ⅞ × 13 ⅞ in.
(42.9 × 35.2 cm)

41. *Untitled*, 2012
Colored pencil
on paper
48 ⅞ × 2 ¼ in.
(124.1 × 183.5 cm)

42. *Untitled*, 2009
Colored pencil and
ink on paper
61 ¾ × 36 in.
(156.8 × 91.4 cm)

43. *Untitled*, 2010
Colored pencil
and ink on paper
68 × 36 in.
(172.7 × 91.4 cm)

44. *Untitled*, 2010
Colored pencil
and ink on paper
68 × 36 in.
(172.7 × 91.4 cm)

45. *Untitled*, 2009
Colored pencil and
ink on paper
61 ¾ × 42 in.
(156.8 × 106.7 cm)

48. *Untitled*, 2009
Felt and ink on
paper
24 × 18 in.
(61 × 45.7 cm)

50. *Untitled*, 2009
Felt and ink on
paper
24 × 18 in.
(61 × 45.7 cm)

51. *Untitled*, 2009
Felt and ink on paper
24 × 18 in.
(61 × 45.7 cm)

53. *Untitled*, 2008
Enamel and mixed
media on canvas
72 × 72 in.
(182.9 × 182.9 cm)

57. *Untitled*, 2008
Mixed media
72 × 60 × 7 in
(182.9 × 152.4 ×
17.8 cm)

61. *Untitled*, 2008
String, fabric, wood,
and mixed media
81 ½ × 34 in.
(207 × 86.4 cm)

62. *Cleanse, Fold
and Manipulate*,
2007
String, carpet, wood,
and mixed media
53 ½ × 21 × 19 in.
(135.9 × 53.3 ×
48.3 cm)

63. *Untitled*, 2008
Mixed media
37 × 47 × 6 in
(94 × 119.4 × 15.2 cm)

65. *Untitled*, 2010
Mixed media
20 ½ × 19 ¼ × 7 ½ in.
(52.1 × 48.9 × 19 cm)

68. *Untitled*, for
Virginia, 2007
Mixed media on
fabric
24 × 17 ½ in.
(61 × 44.5 cm)

69. *Jungle Fever*,
2007
Mixed media on
fabric
54 × 30 × 3 in.
(137.2 × 76.2 ×
7.6 cm)

73. *Untitled*, 2011
Mixed media
16 × 34 × 9 in.
(40.6 × 86.4 ×
22.9 cm)

74. *Cleanse, Fold
and Manipulate*,
2007
String, carpet, wood,
and mixed media
53 ½ × 21 × 19 in.
(135.9 × 53.3 × 48.3 cm)

76. *Untitled*, 2008
Mixed media
28 × 18 × 82 in.
(71.1 × 45.7 × 208.3 cm)

77. *Was Raised by a
Pantomime's Hands*,
2007
Glazed ceramic,
string, glue, plaster,
cardboard, wood,
fabric, and mixed
media
Sculpture: 70 × 18 ×
13 ½ in. (177.8 ×
45.7 × 34.3 cm)
Fabric Element:
42 ½ × 38 in.
(123.2 × 96.5 cm)

79. *Spaghetti Tower*,
2012
Wood, string, nails,
and acrylic
33 ½ × 11 × 9 in.
(85.1 × 28 × 22.9 cm)

82. *Untitled*, 2012
Glazed ceramic
20 ½ × 9 × 8 ½ in.
(52.1 × 22.9 × 21.6 cm)

83. *Untitled*, 2012
Glazed ceramic
11 × 6 ½ × 20 in.
(27.9 × 16.5 × 50.8 cm)

87. *Untitled*, 2011
Ceramic
10 ¼ × 13 ¾ × 6 ½ in.
(26 × 34.9 × 16.5 cm)

91. *Untitled*, 2012
Glazed ceramic
18 ½ × 10 ½ × 10 ½ in.
(47 × 26.7 × 26.7 cm)

92. *Brother*, 2012
Glazed ceramic
13 ½ × 12 × 9 in.
(34.3 × 30.5 × 22.9 cm)

95. *Chester*, 2012
Powder coated
steel
31 × 35 ½ × 10 in.
(78.7 × 90.2 × 25.4 cm)

Contributors

Naomi Beckwith, the MCA's Marilyn and Larry Fields Curator, was formerly Associate Curator at the Studio Museum in Harlem, where she focused on themes of identity and conceptual practices in contemporary art, artists of African descent, and managing the Artists-in-Residence program. Prior to her tenure at the Studio Museum, Beckwith was the 2005–07 Whitney Lauder Curatorial Fellow at the Institute of Contemporary Art, Philadelphia, where she worked on numerous cutting-edge exhibitions including *Locally Localized Gravity* (2007), an exhibition and program of events focused on more than 100 artists whose practices are social, participatory, and communal. Beckwith has also been the BAMart project coordinator at the Brooklyn Academy of Music and a Helena Rubenstein Critical Studies Fellow at the Whitney Museum of American Art. She has curated and cocurated exhibitions at New York alternative spaces Recess Activities, Cuchifritos, and Artists Space. Beckwith received an MA with Distinction from the Courtauld Institute of Art in London, completing her master's thesis on Adrian Piper and Carrie Mae Weems, and a BA in history from Northwestern University in Illinois. She was a 2009 grantee of the Andy Warhol Foundation for the Visual Arts, and was named the 2011 Leader to Watch by ArtTable.

Jason Foumberg is the contributing art critic at *Chicago* magazine, and editor of the art section at *Newcity*, an alt-weekly newspaper in Chicago. He contributes art criticism to *frieze*, *Sculpture*, and *Photograph* magazines, and has contributed exhibition catalogue essays for the MCA, Columbia College Chicago, Loyola University Museum of Art, DePaul Art Museum, and threewalls, among others.

Trevor Smith is Curator of the Present Tense at the Peabody Essex Museum in Salem, MA, where he has commissioned new works from Charles Sandison, Susan Philipsz, Michael Lin, and Candice Breitz, among others. Prior to joining the Peabody Essex, Smith was Curator in Residence at the Center for Curatorial Studies, Bard College. From 2003–06, he was Curator at the New Museum in New York where, among other projects, he cocurated the widely acclaimed exhibition *Andrea Zittel: Critical Space* and presented a major survey of the work of Brian Jungen. Smith was born in Canada and studied art history at the University of British Columbia. From 1992–2003, he was based in Australia, where he worked first at the Biennale of Sydney, then as Director of the Canberra Contemporary Art Space, and finally as Curator of Contemporary Art at the Art Gallery of Western Australia. He has produced more than fifty exhibitions and published widely in North America, Europe, Australia, and Asia.

This book is published on the occasion of the exhibition *William J. O'Brien*, organized by the Museum of Contemporary Art Chicago, organized by Marilyn and Larry Fields Curator Naomi Beckwith, and presented in the Bergman Family Gallery at the Museum of Contemporary Art Chicago, January 25–May 18, 2014.

Published as part of the series MCA Monographs by the Museum of Contemporary Art Chicago and ARTBOOK | D.A.P.

Produced by the Design, Publishing, and New Media Department of the Museum of Contemporary Art Chicago. Edited by Senior Editor Lisa Meyerowitz, Consulting Editors David Peak and Lauren Weinberg, and former Editor Sarah Kramer; with the assistance of Manager or Rights and Images Christia Crook and Rights and Images Assistant Katie Levi.

Designed by Scott Reinhard Co., Chicago.

Typeset in Monotype Grotesque.

Printed by The Avery Group at Shapco Printing, Inc., Minneapolis

ISBN 978-1-938922-16-9

Museum of Contemporary Art Chicago
220 East Chicago Avenue
Chicago, IL 60611
mcachicago.org

Copublished and distributed by
ARTBOOK | D.A.P.
155 Sixth Avenue, 2nd Floor
New York, NY 10013
Tel: (212) 627-1999
Fax: (212) 627-9484

Library of Congress
Cataloging-in-Publication Data

William J. O'Brien / Naomi Beckwith.
 pages cm -- (MCA monographs)
 "This book is published on the occasion of the exhibition William J. O'Brien, organized by the Museum of Contemporary Art Chicago, curated by Naomi Beckwith, and presented in the Bergman Family Gallery at the Museum of Contemporary Art Chicago, January 25-May 18, 2014."
 Includes bibliographical references.
 ISBN 978-1-938922-16-9
 1. O'Brien, William J., 1975---Exhibitions. I. Beckwith, Naomi, author.
World created. II. Smith, Trevor, 1964- author.
In lumpen bits. III.
Foumberg, Jason, author. Goblin-Buddha Codex. IV. Museum of Contemporary Art (Chicago, Ill.)
N6537.O25A4 2014
709.2--dc23

 2013041732

Photo Credits

Every reasonable attempt has been made to locate the owners of copyrights in the book and to ensure the credit information supplied is accurately listed. Errors or omissions will be corrected in future editions.

All artworks by William J. O'Brien and photographs of the artist's studio are reproduced courtesy of the artist; Marianne Boesky Gallery, New York; and Shane Campbell Gallery, Chicago. Photographers: Tom Van Eynde, William Joyce, Jason Wyche, and Nathan Keay.

P. 22, fig. 1: Photo © MCA Chicago. © 2013 The LeWitt Estate/Artists Rights Society (ARS), New York; **fig. 2:** © 2013 The LeWitt Estate/Artists Rights Society (ARS), New York. Courtesy of L.A. Louver, Venice, CA.; **p. 26, fig. 3:** Courtesy of Milwaukee Art Museum; **p. 29, fig. 4:** Courtesy of Mike Kelley Foundation for the Arts. All Kelley Works © Estate of Mike Kelley. All rights reserved. Photo: Nathan Keay, © MCA Chicago; **p. 29, fig. 5:** Art © Estate of David Smith/Licensed by VAGA, New York, NY. Photo: Jerry L. Thompson; **p. 30, fig. 6:** Art © Judd Foundation/Licensed by VAGA, New York, NY. Photo: Kerry McFate, courtesy of Pace Gallery; **p. 33, fig. 7:** photo: Henrik Gaard, courtesy of the artist; **p. 34, fig. 8:** Sonnabend Gallery, New York. © 2013 Robert Morris/Artists Rights Society (ARS), New York; **p. 36, fig. 9:** Collection Museum of Contemporary Art Chicago, restricted gift of Carlos and Rosa de la Cruz; Bernice and Kenneth Newberger Fund, 1995.11. © The Felix Gonzalez-Torres Foundation, courtesy of Andrea Rosen Gallery, New York. Photo: Nathan Keay, © MCA Chicago; **p. 36, fig. 10:** Los Angeles County Museum of Art, purchased with funds provided by the Graphic Arts Council, the Los Angeles County Fund by exchange, the Modern and Contemporary Art Council, Tony Ganz, and Dorothy Sherwood (M.2004.2.2). Art © Judd Foundation/Licensed by VAGA, New York, NY. Digital image © 2013 Museum Associates/LACMA. Licensed by Art Resource, NY. Licensed by Art Resource, NY; and **p. 45, fig. 1:** Photo: Horace Aand, courtesy of the artist and Veneklasen Werner, Berlin.